Formosa Aborigines

Hsuan Chung

Forward

Taiwanese aborigines are optimistic. They accept life as it is, and live in harmony with nature. Their languages are also the very origins of Austronesian languages. However, as the Dutch East India Company, set foot in Taiwan in the early 17th century, a succession of ethnic conversion, integration and changes were introduced. The Taiwanese aborigines were ruled under external forces for 500 years; from the colonization of the Netherlands in 1922, the Qing Dynasty in 1683, and the Japanese, under whose rule they have been persecuted, oppressed, and controlled. When the KMT (Kuomintang, often translated as the Nationalist Party of China) retreated to Taiwan from China, the aborigines continued to try to survive and to coexist with other ethnic groups.

Before the KMT, the Taiwanese aborigines had never been exposed to Chinese Confucian culture. After the KMT gained its legitimacy, it ruled with an iron fist, and implemented various policies to expedite the subjugation of the aboriginal people and the eradicating their of traditional culture. In terms of education, propaganda was used to insinuate that the aboriginal culture was barbaric. The KMT required that aboriginal people speak only in Chinese, forbidding them from speaking their mother tongue, and forced them to adopt Chinese names. Those policies had drastically changed the traditional structure of the aboriginal people, and affected their minds and their understanding of their own ethnicity. This led to feelings of inferiority and confusion, and the denial of their own bloodline and culture, thus resulting in their acceptance of the Han Chinese culture.

The aborigines were once the group of people that were closest to nature. However, as the wheel of time turned and the society changed, they were forced to abandon their traditional culture and beliefs, and eventually succumbed to the tides of history. Now only exist a small number of people who still abide by the culture and ancestral teachings today. Faced with the dominant Han culture, young aboriginal people are still confronted with self-doubt and denial of the value of their traditional culture even now, to the point where they do not dare to acknowledge their own identity. The Han people, with their advantageous ruling position, had plundered the indigenous people of the land and property. Indigenous people were given different names in different colonial periods, all of them derogatory and discriminatory. It wasn't until the early 1990s when the terms were rectified and officially corrected to towards Aborigines – the people who originally live there.

Taiwan (Formosa) was an extremely beautiful island, and is said to be the origin of Austronesian languages. The ancestors of the aborigines were the guardians of Formosa; they lived on this land with modesty and discipline. They were humble, optimistic, simple, and courageous. However, the lack of opportunities for education had left them in a disadvantage when faced with one after another invasion. In the course of history, they were used, oppressed and slaughtered.

In this series of photography, I try to present the uniqueness and cultural characteristics intrinsic to the aborigines. Within the frame, what the works are focused on is the aboriginal people as a whole, rather than individuals or certain figures, as the issues given rise to by historical incidents are not unique to just one group of people or just certain individuals. When I photograph the subjects, I intentionally blurred their facial features and avoid presenting their face in its entirety in the picture. Through long exposure and simulation, I seek to break the bond of time and present the lives of the aborigines' ancestors on this island with the images captured in the present. From their initial carefree way of life where they lived in harmony with nature, to the oppression forced upon them by their invaders, the works portrait the fundamental changes in their way of life and their mental state. Unfortunately, the issues presented in the works still exist today - from the most basic matters as habitation, unemployment and education, to high suicide rate and of self-doubt and the denial of one's own cultural values. The ideas that aborigines tend to be less educated and inferior to the Han people persist today.

Hsuan Chung

2018

Lasda Takbanuaz

Autobiography

In every generation, the public has different opinions about us. Taiwan was in a state of martial law for 38 years after the February 28 incident in 1947. Taiwanese's culture was born just a few years before the end of the martial law. The gradual rise of equal transitional justice at the time (tribal opposition - martial law - the first presidential direct election in 1996), under the government's continued advocacy of confrontation and conflict, the socially obvious prejudice and discrimination implicitly turned directly from the previous generation, imposing on our generation.

When I was teenager, that I started to realize I was different from other people. In the face of Taiwan's system of further studies, even in class groups, when people began to use race as a distinction and joke, I started to become aware that the relationship between people is not as simple as when I was young. When I was the teenager, in middle school, people always call me "Fan Tsai," or "Mountain Tsai." In the Taiwanese Language, "Tsai" has scornful meaning. I did not realize the discrimination, at that time I only realized that I felt different from others and I was a little uncomfortable. The public has a different view and symbolic role for us. At the time, our classmates used complex emotions, and whisper said: "you guys have the compensation given by the government or you have subsidies and extra credit" to relieve the inner feelings of incomprehension, embarrassment or unfairness to aborigines.

As a result in workplaces and social settings, I don't like to tell people my true identity or cultural heritage. Looking back now, it carries some labels at that time. To cater to other people's opinions, I realized that I am different from other people. It is common to be stereotyped. In cities, people look at me with different bloodlines, when I returned to the tribe, it seemed to be alienated with the tribe. I feel divorced and out of touch no matter where I am. It made me start to look directly at my ethnic identity since my father passed away five years ago.

My father has a slight intimacy with the tribe because of my grandfather's career. Father and grandfather both were soldiers. In these two generations, because of the military, our life and education were better than the rest of the tribe, but it also keeps a certain distance with neighbors. My brothers and sisters of my peers more alienated, and estranged to the tribe. In the city, in the tribe, I seem to have lost the meaning of "home." This continued to have a tremendous impact on me even until now. A few years before my father passed away, I often went back home to help my father work on land preparation and farming. My father always hoped to have a piece of Canaan in our hometown of Taitung. During that period, I often worked with my father in my hometown, which made me reconnect with the tribe. I reconnected with my ethnic group and blood and restored my feelings with my father and families.

In society and my heritage, I have experienced emotions ranging from being confused, national pride, searching, and rebirth. For now, If someone asks me about my ancestry and identity, it is not pride or inferiority that I feel. It's acceptance and understanding. I believe in Taiwan's society, the sense of estrangement that makes us, culture, and tribe are no way to "accept" a place we are different from others. Also, there is no real way to "understand" the connection between itself and the blood source. Those "different cognitions" are come from misunderstandings and vague histories, which makes the gap between alienation, and alienation more hidden among the younger generation of Taiwanese aborigines.

Lasda Takbanuaz

2018

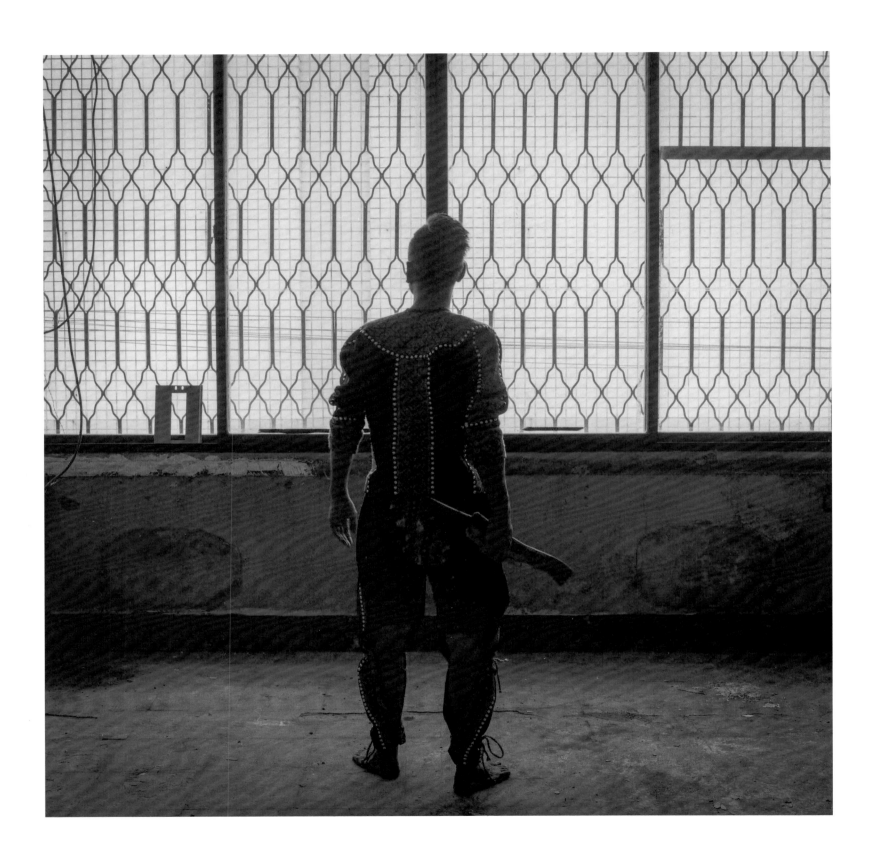

Formosa Aborigines

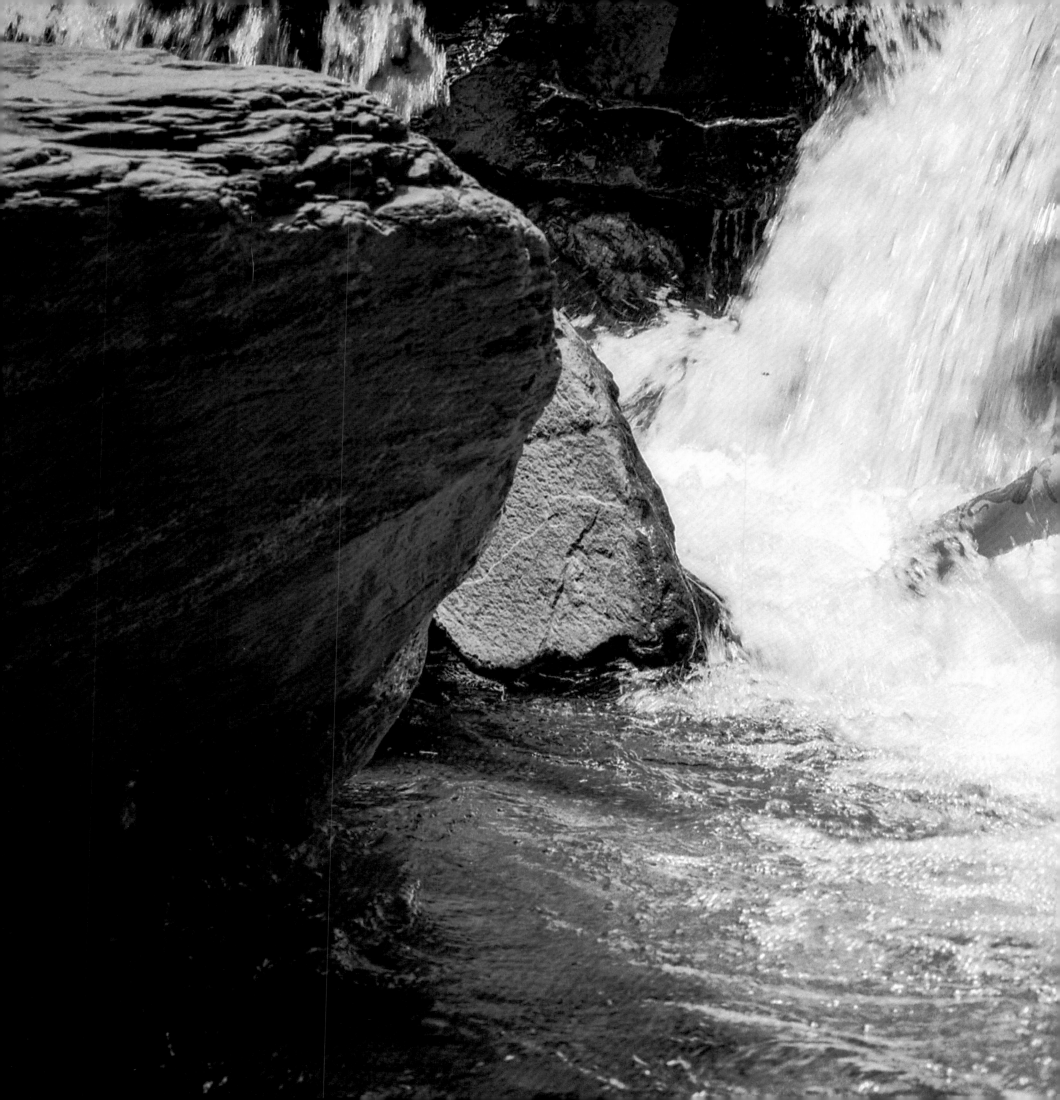

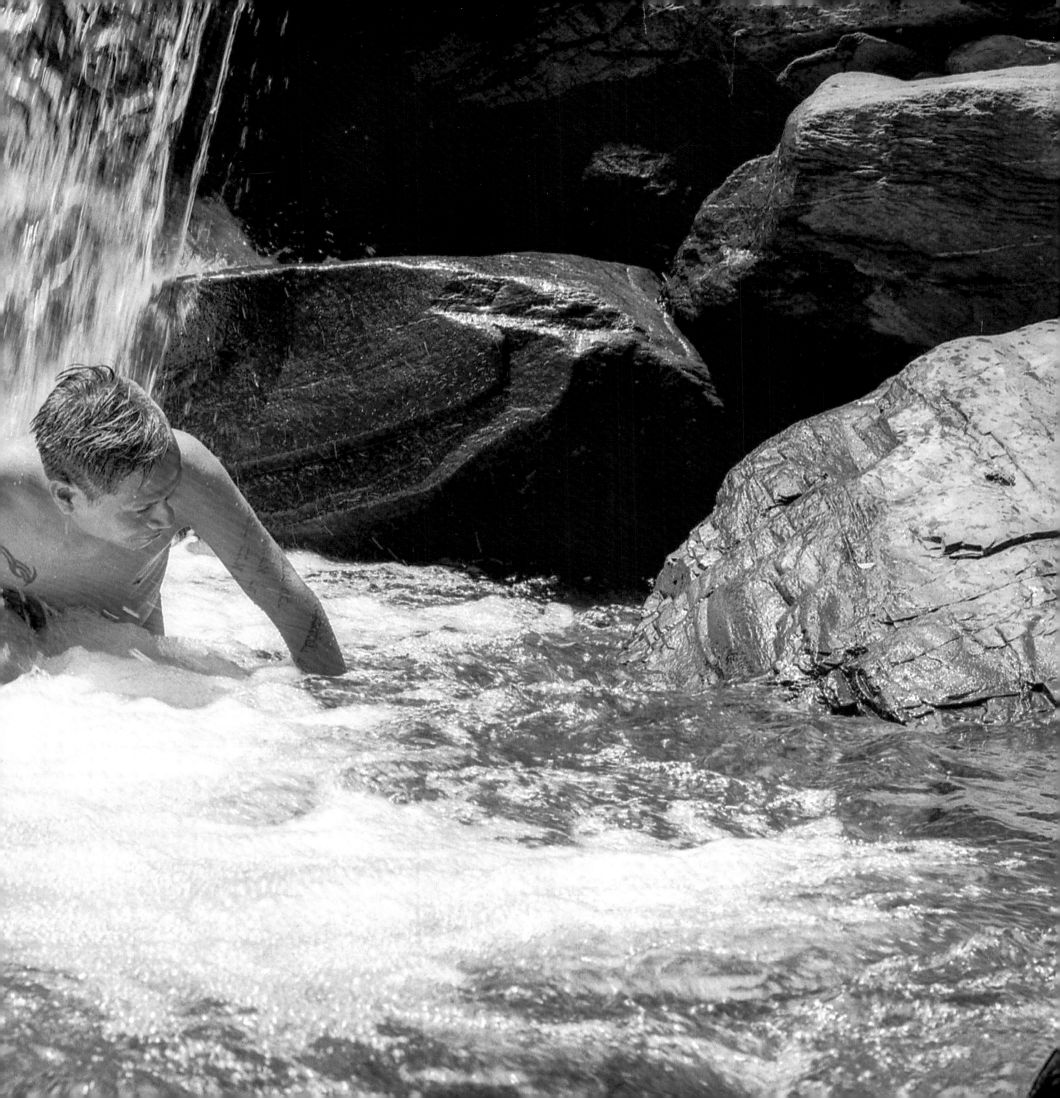

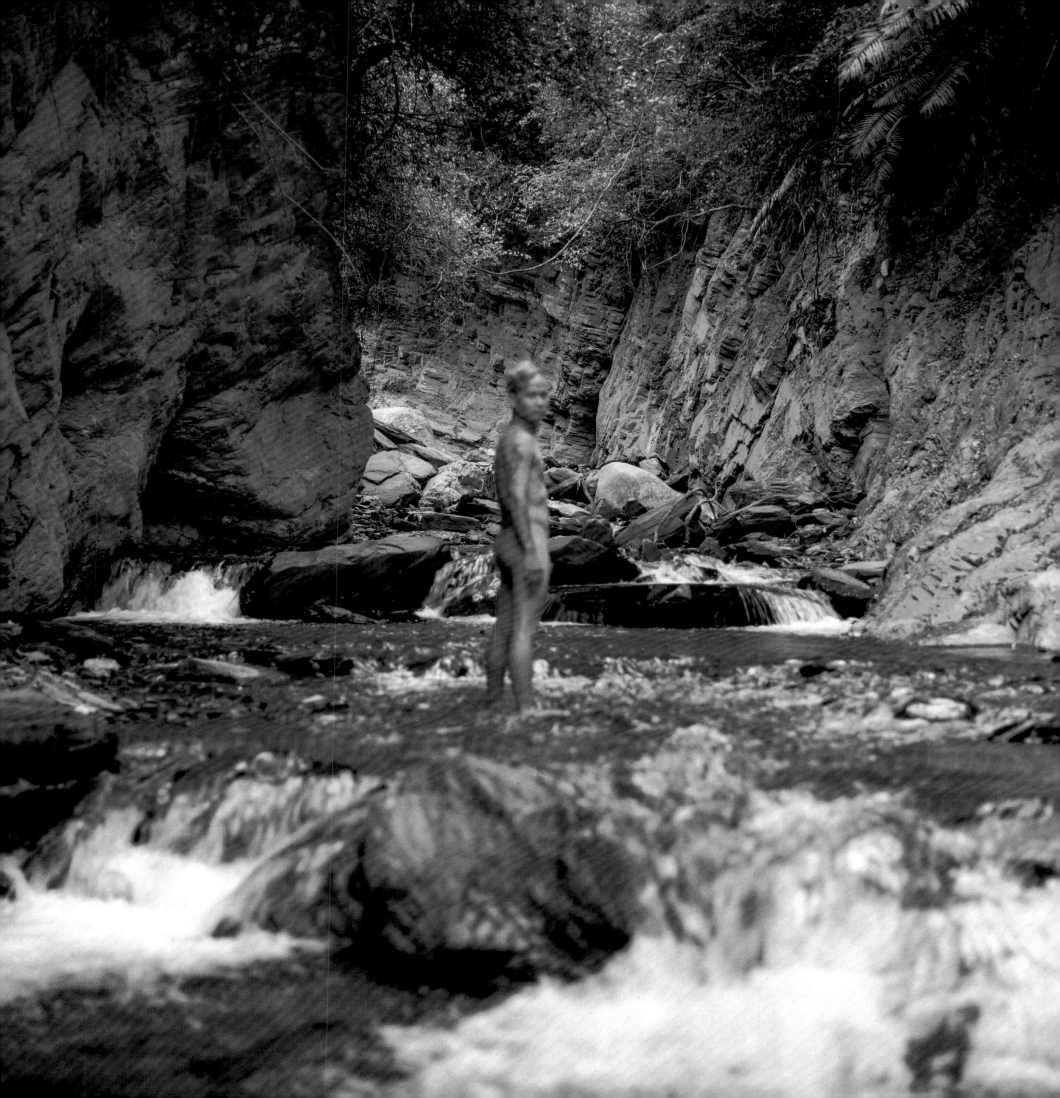

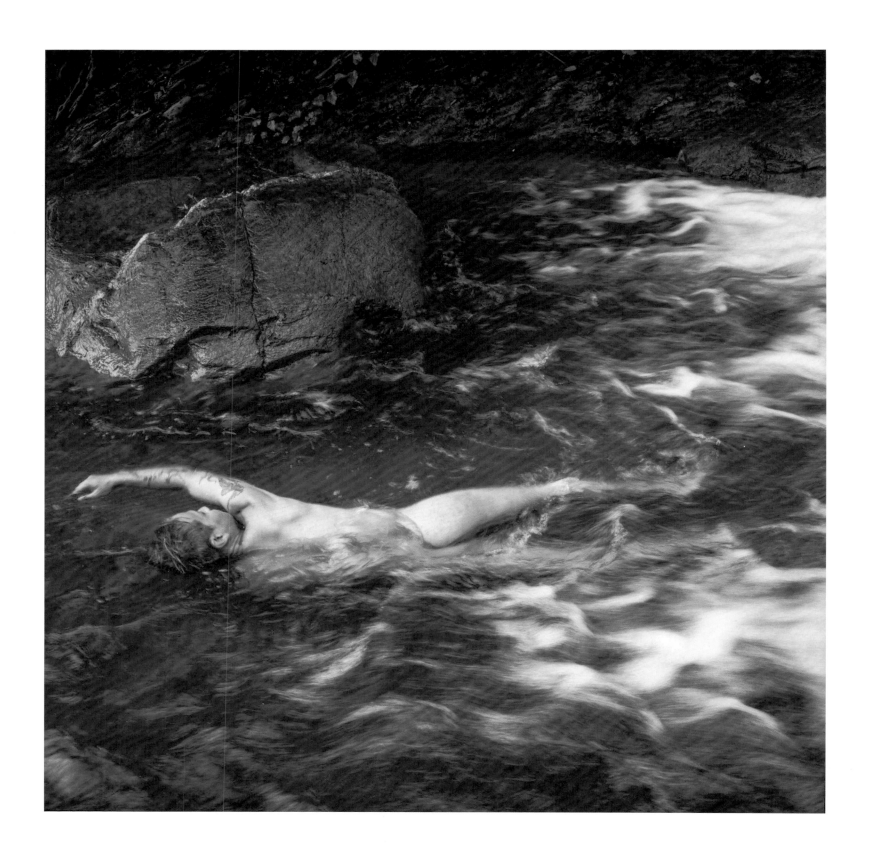

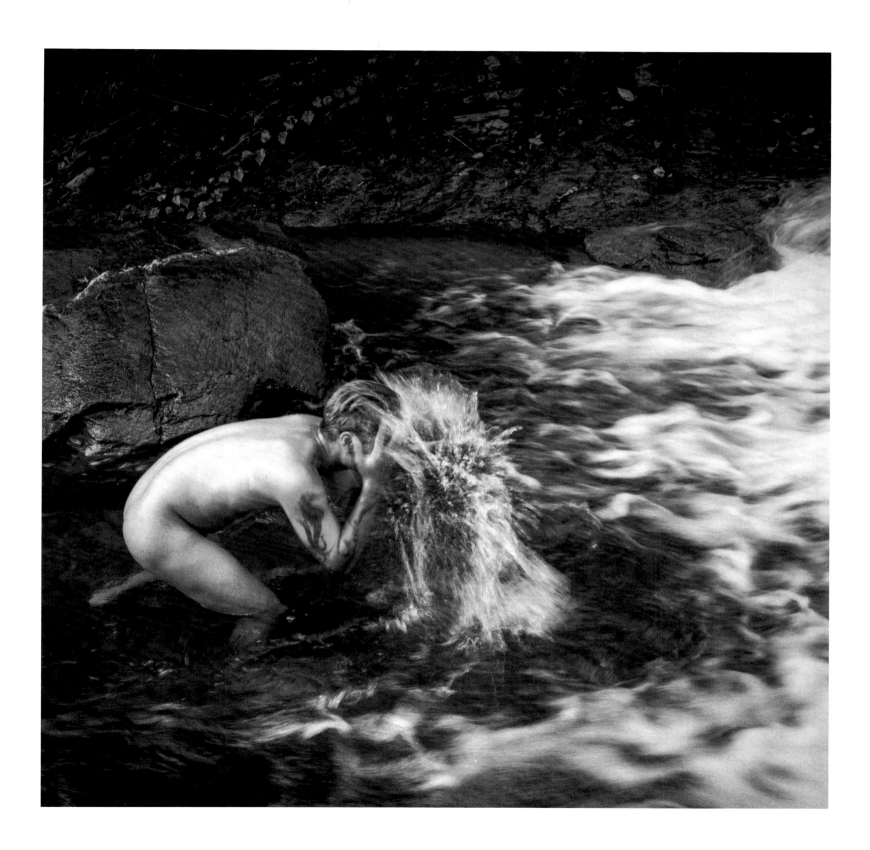

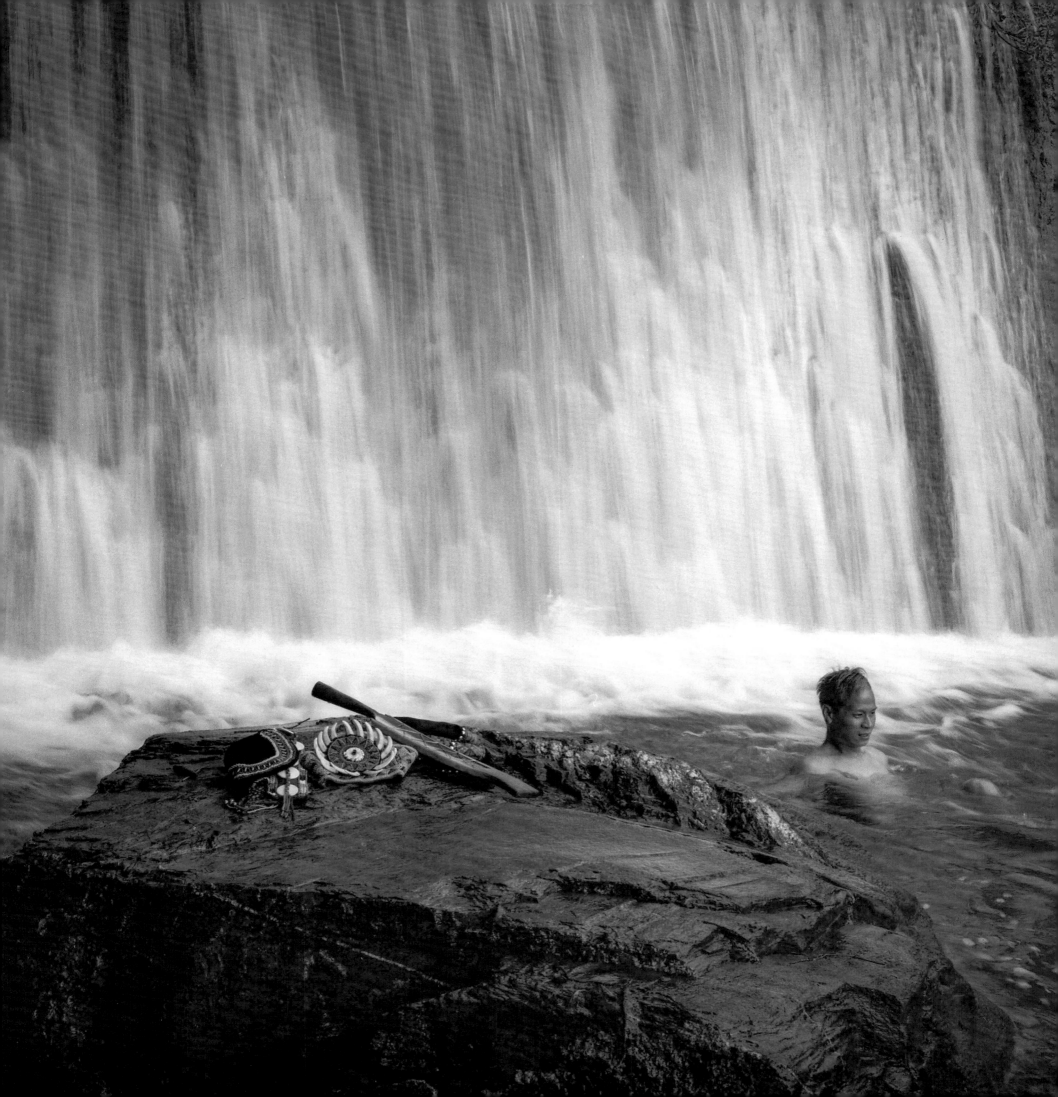

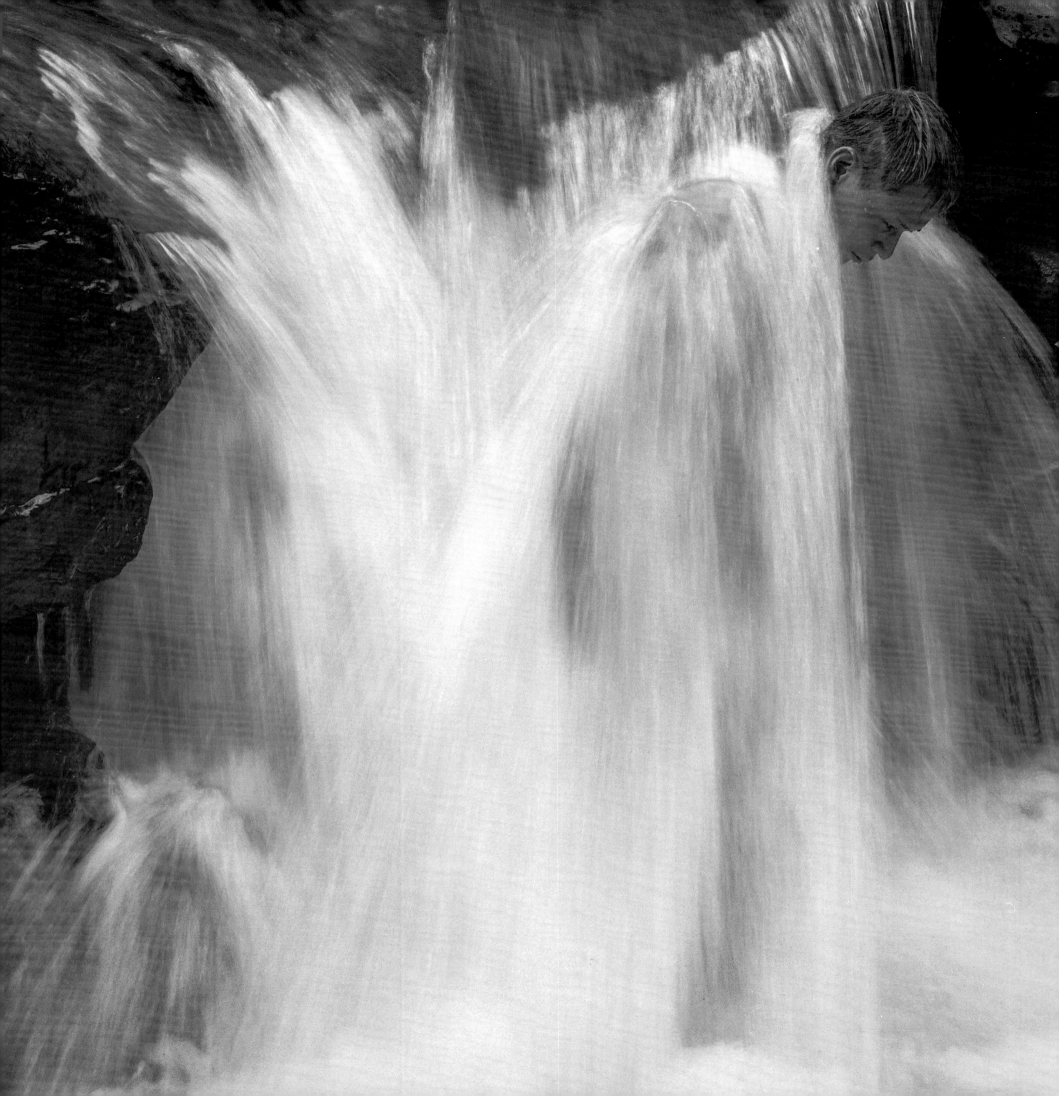

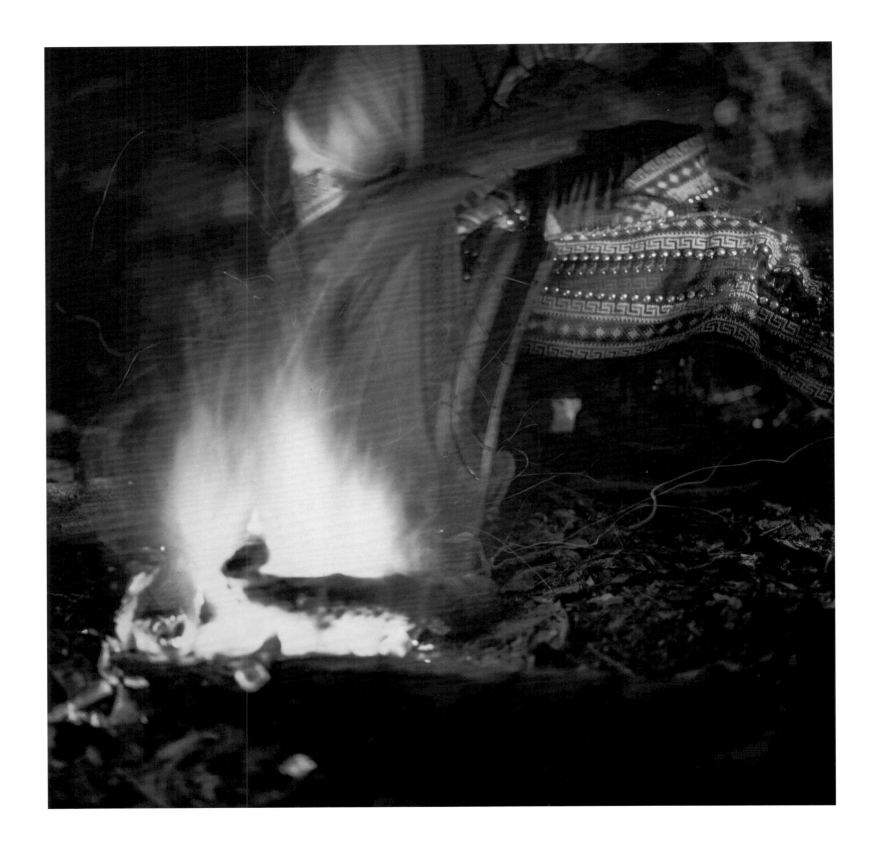

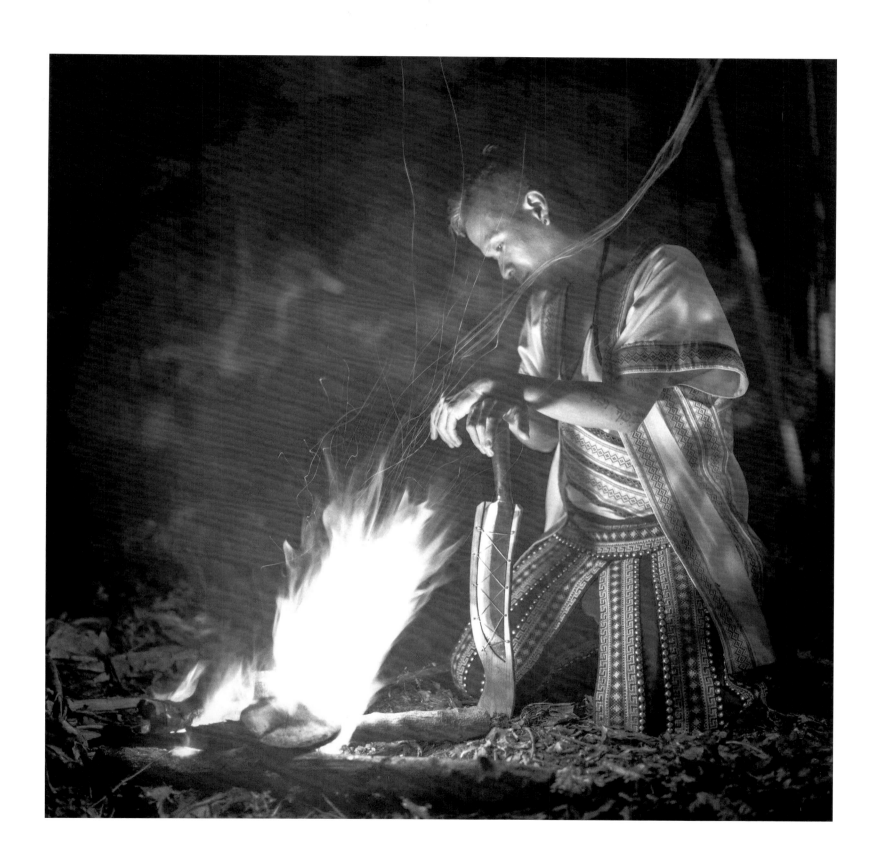

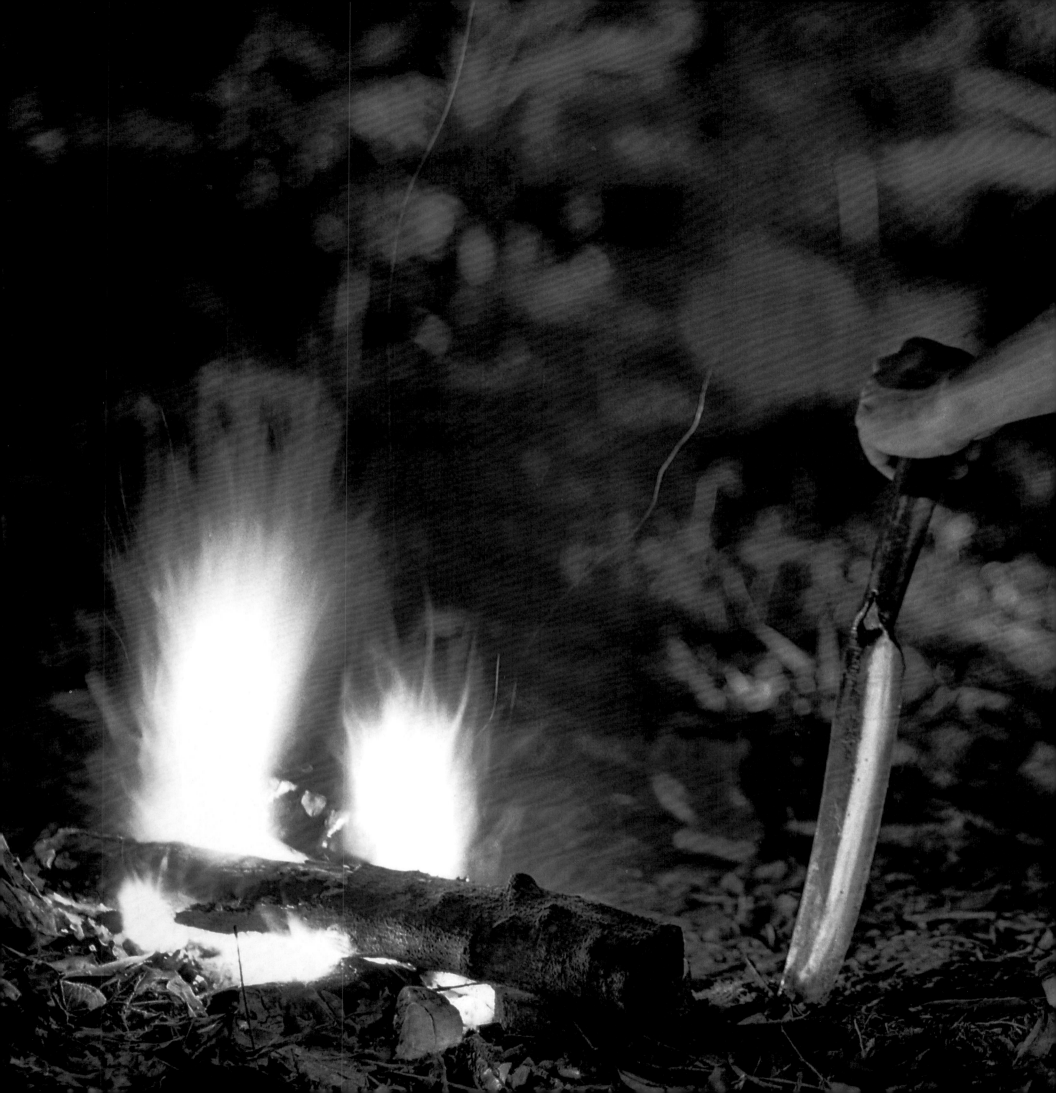

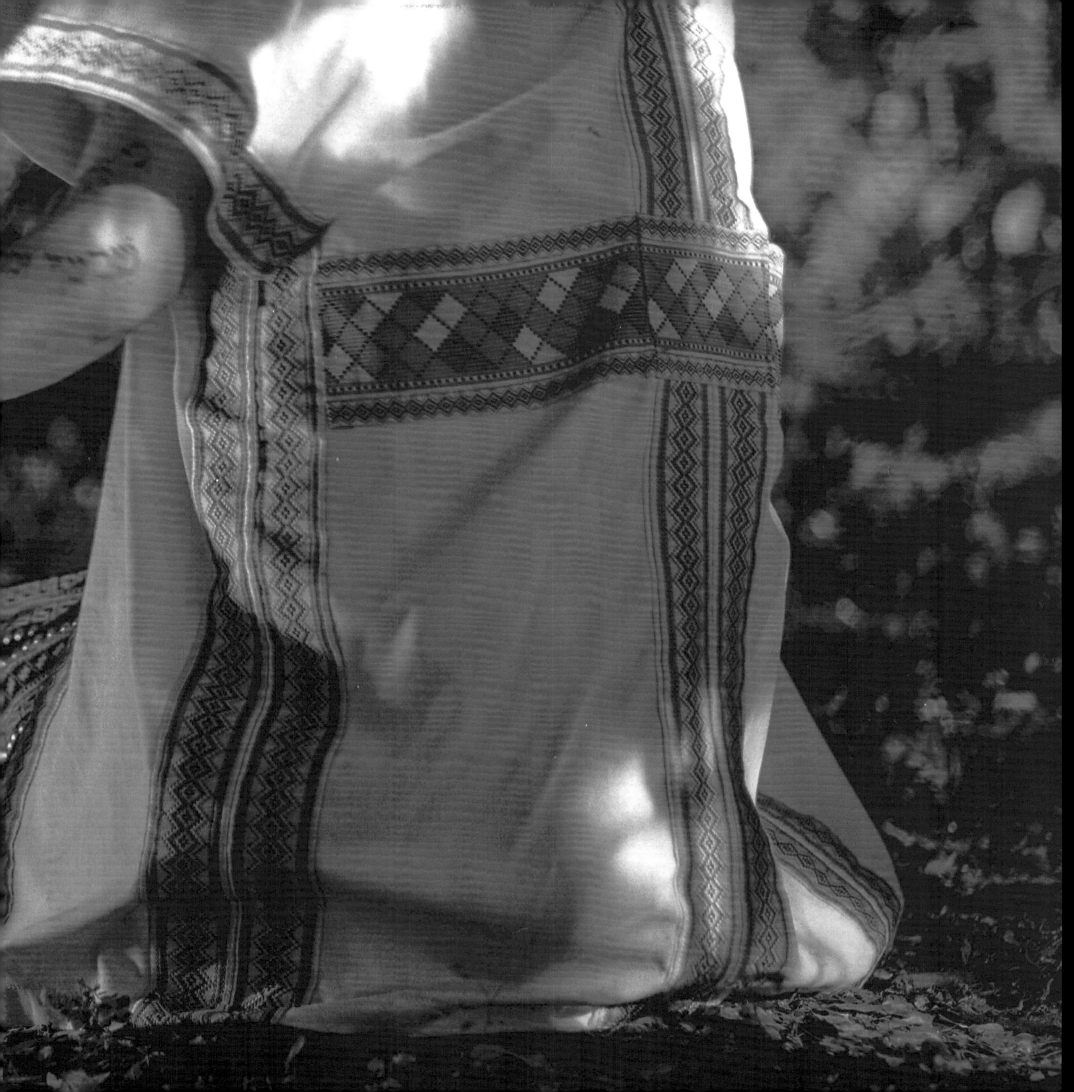

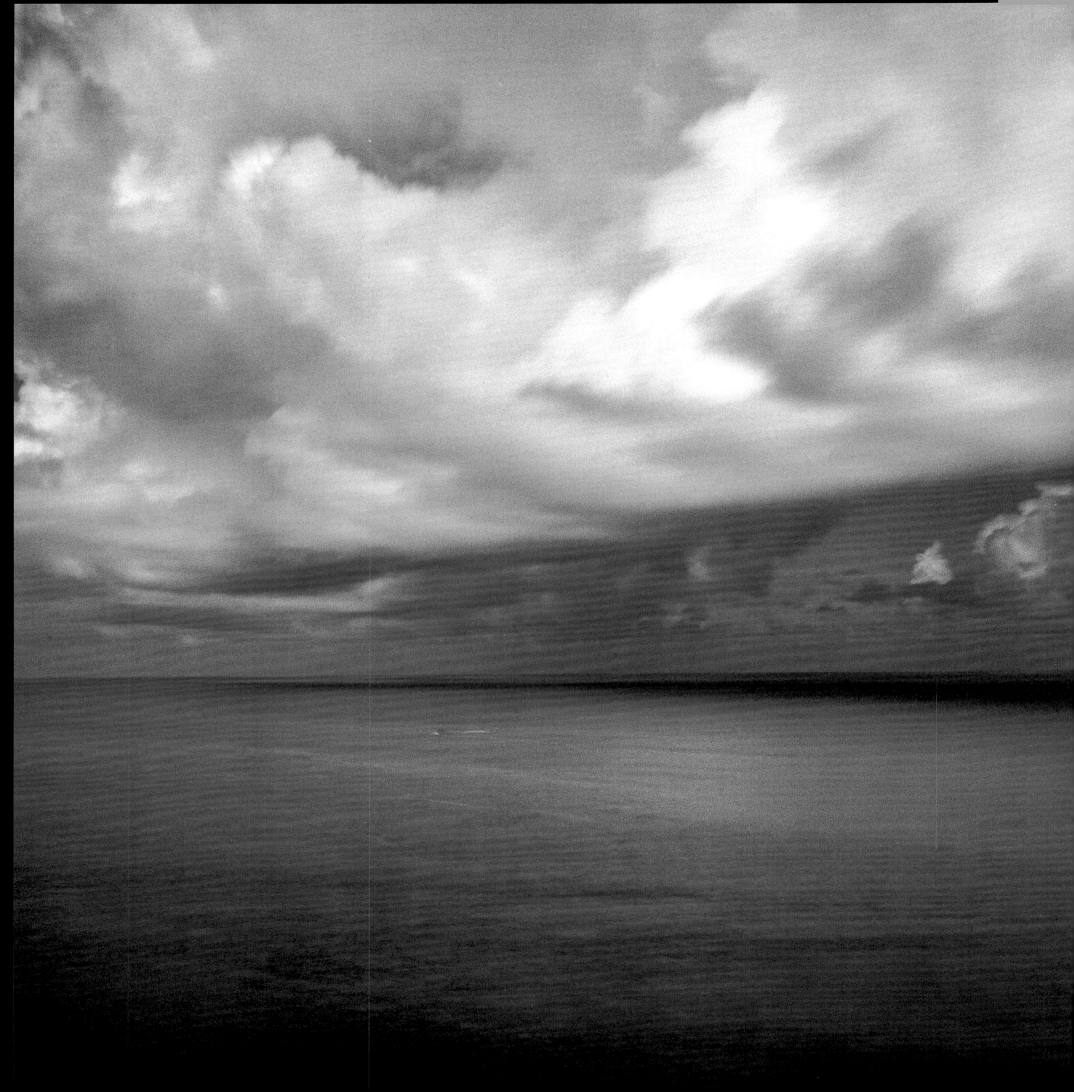

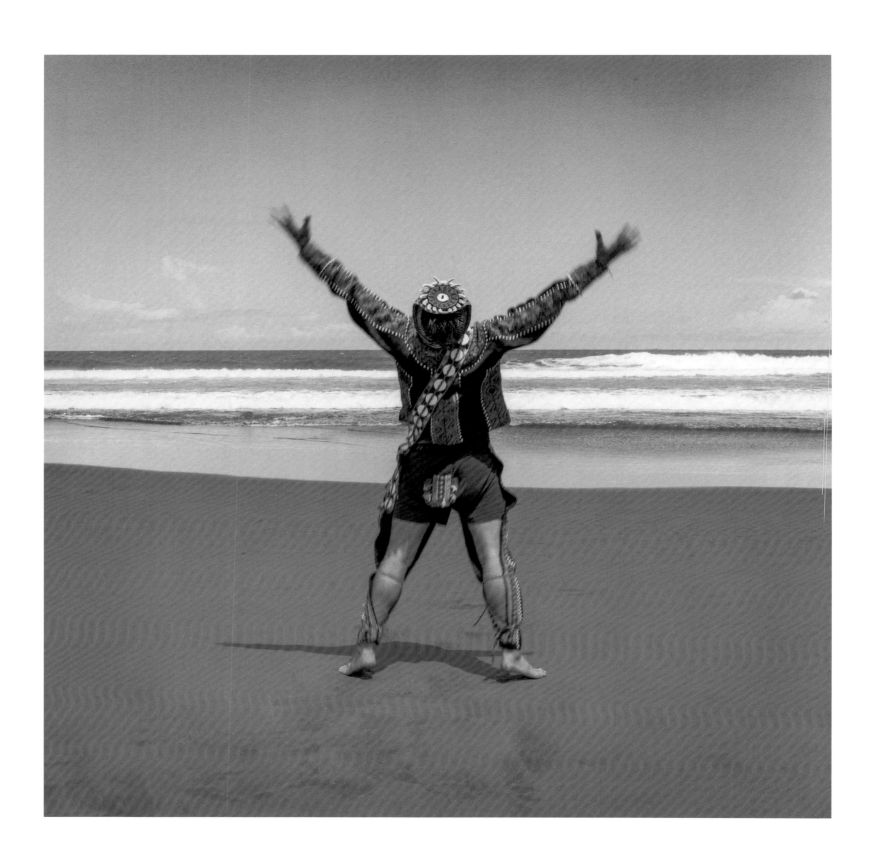

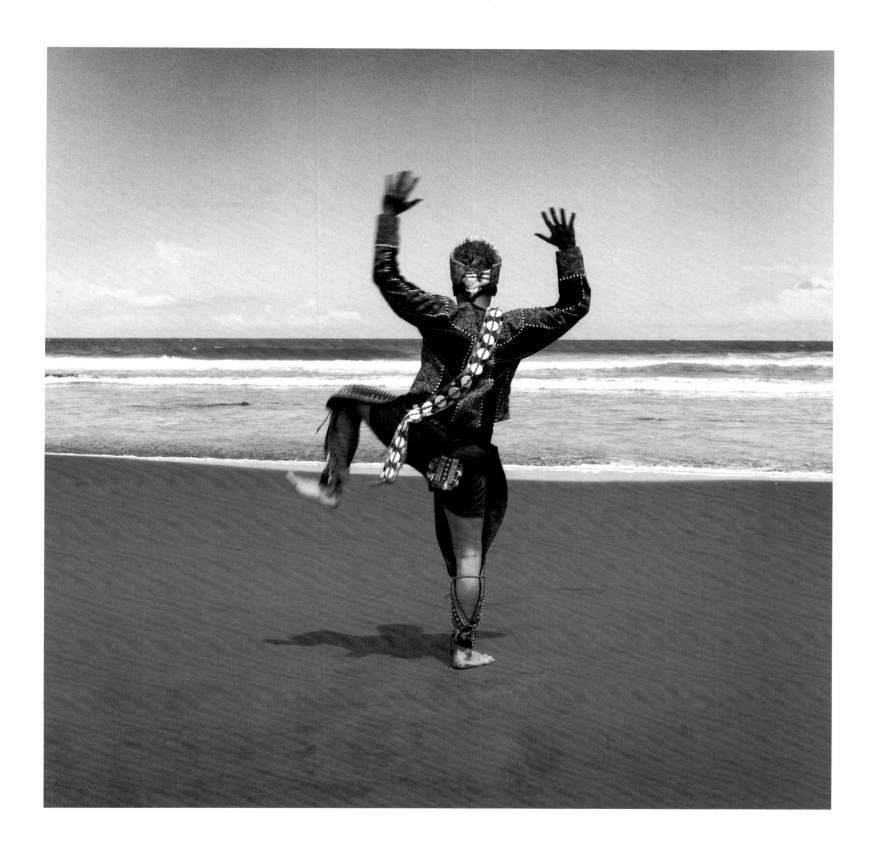

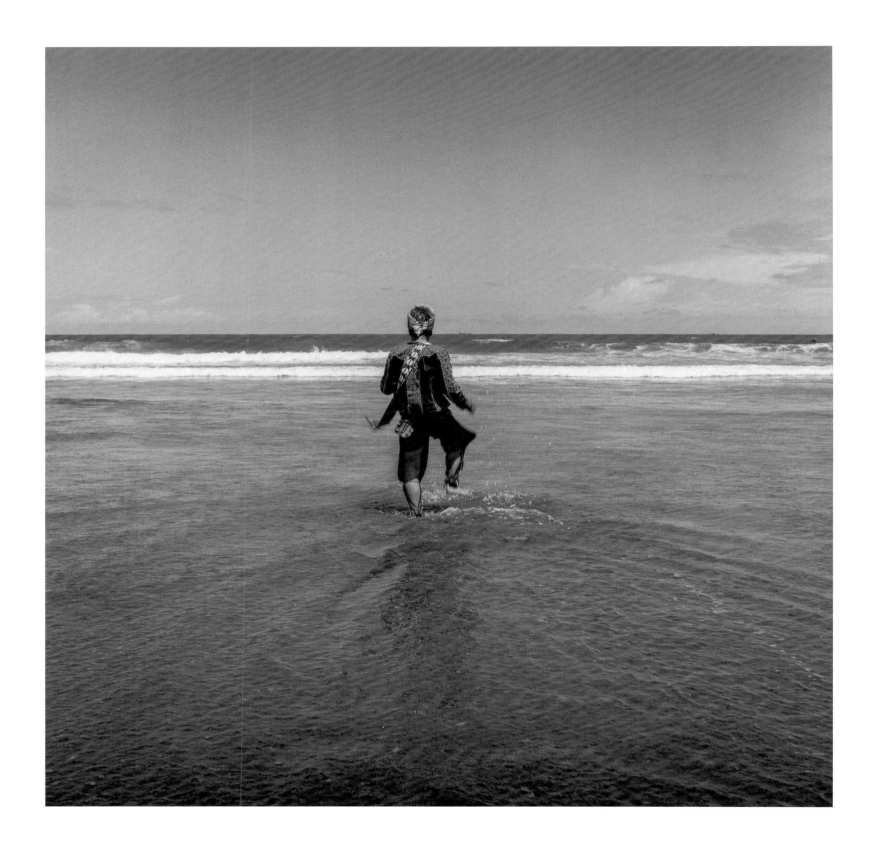

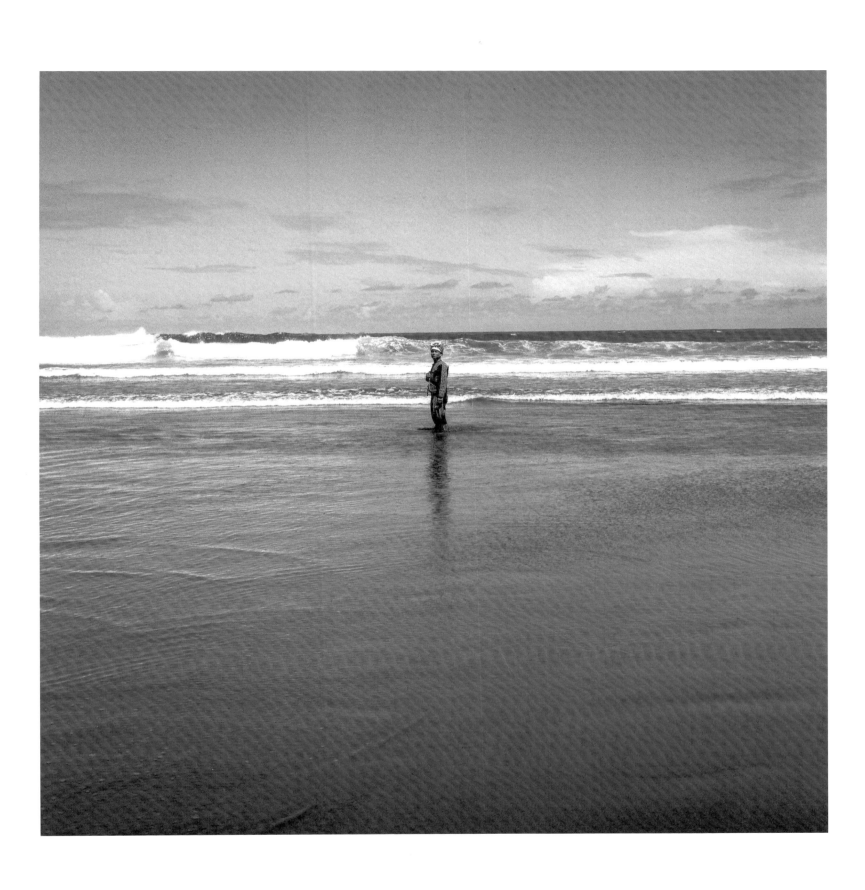

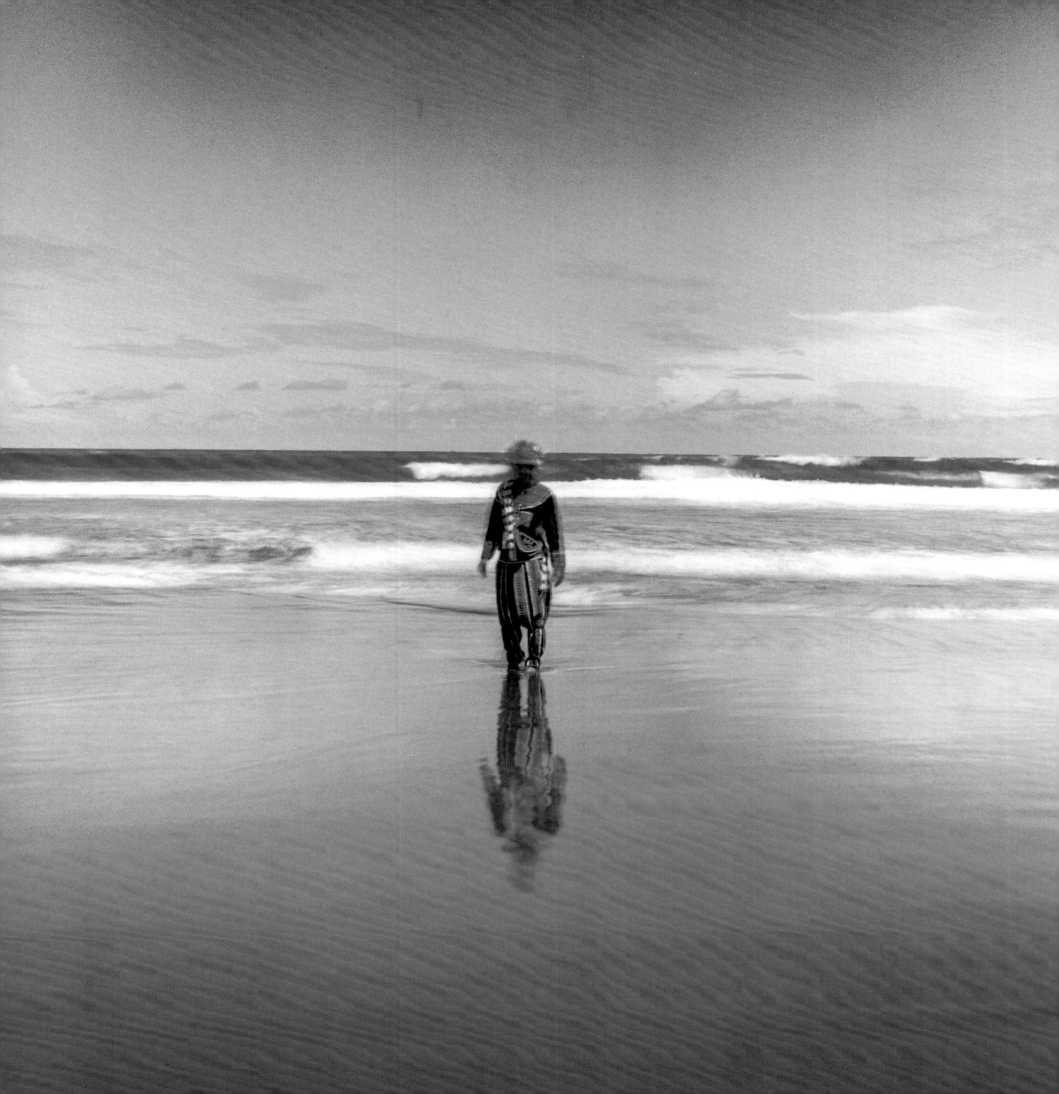

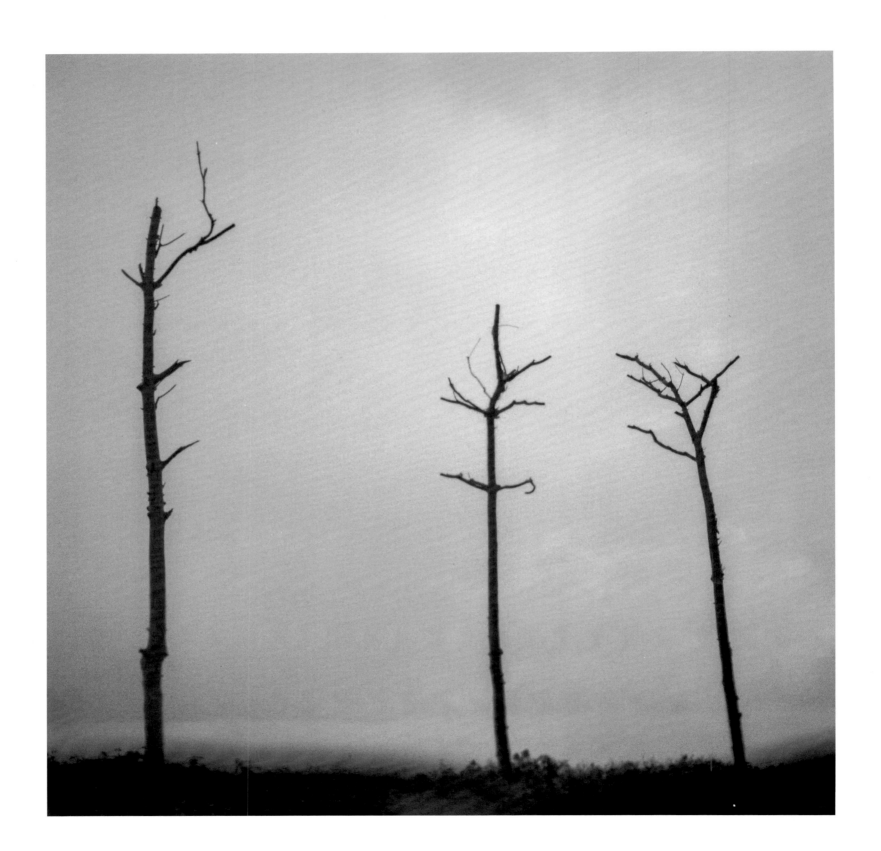

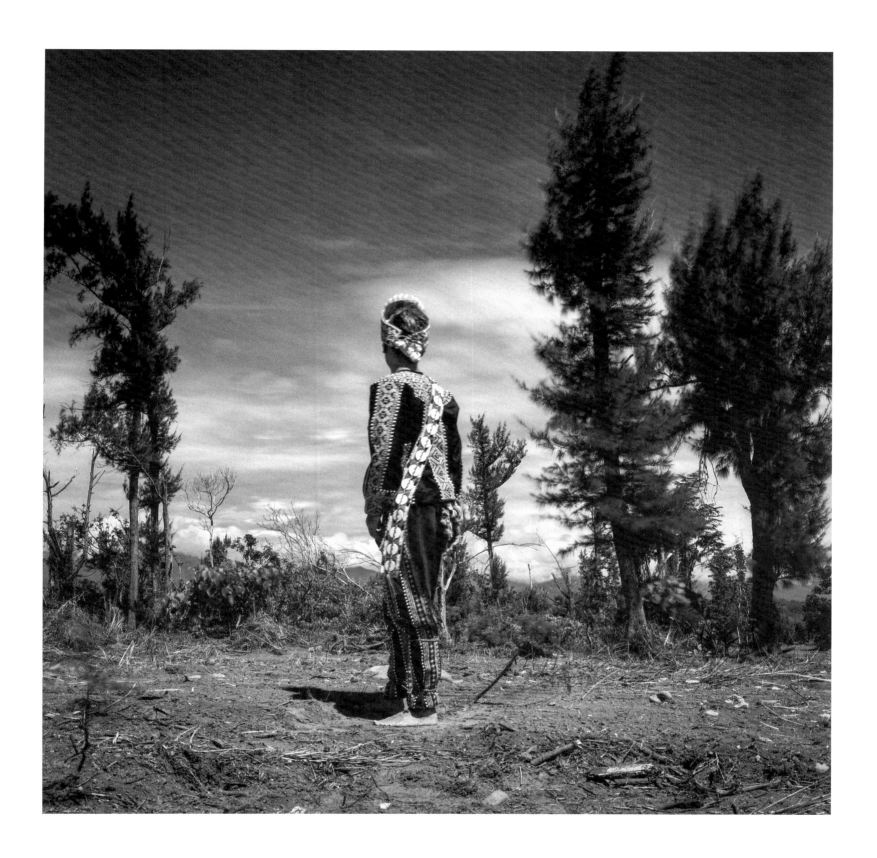

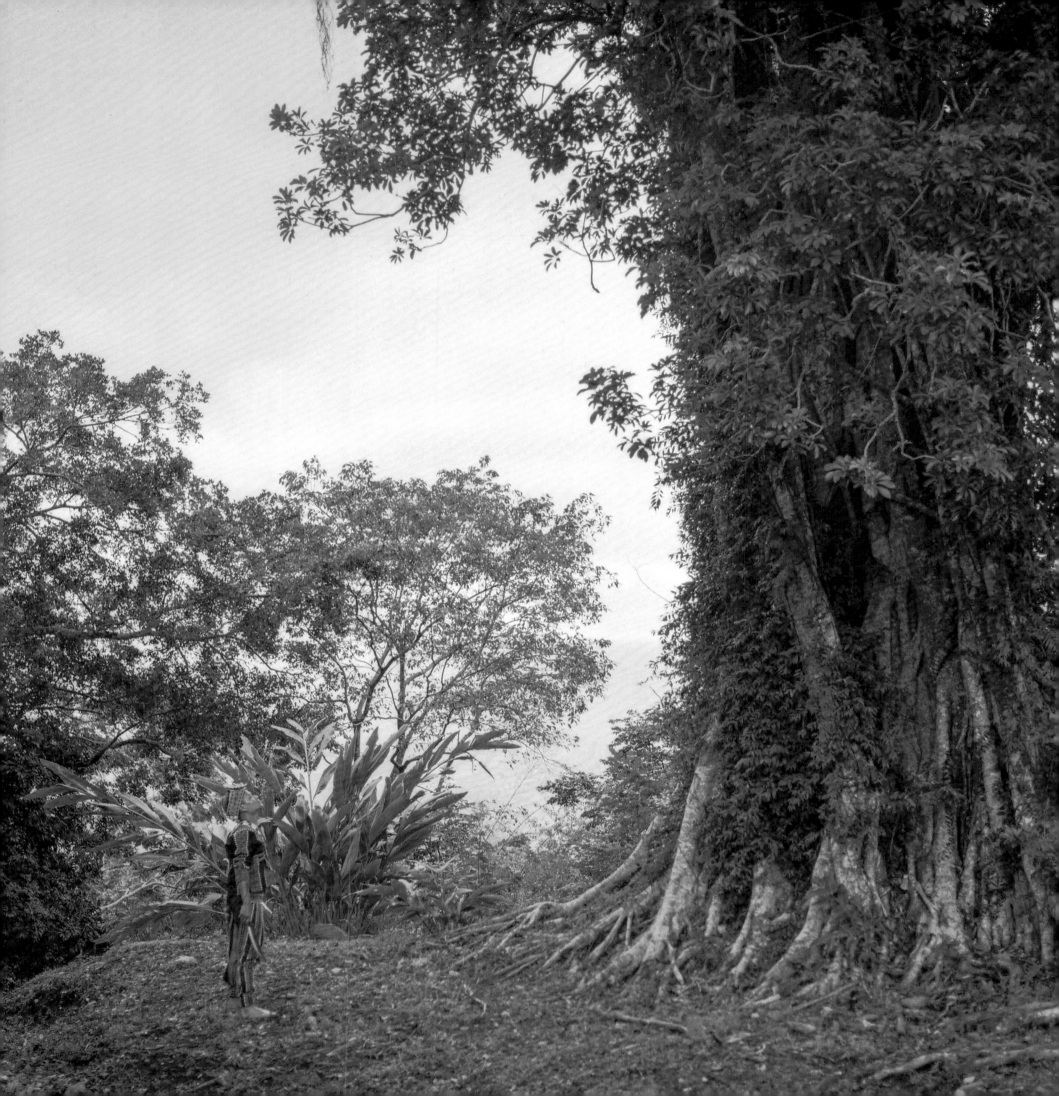

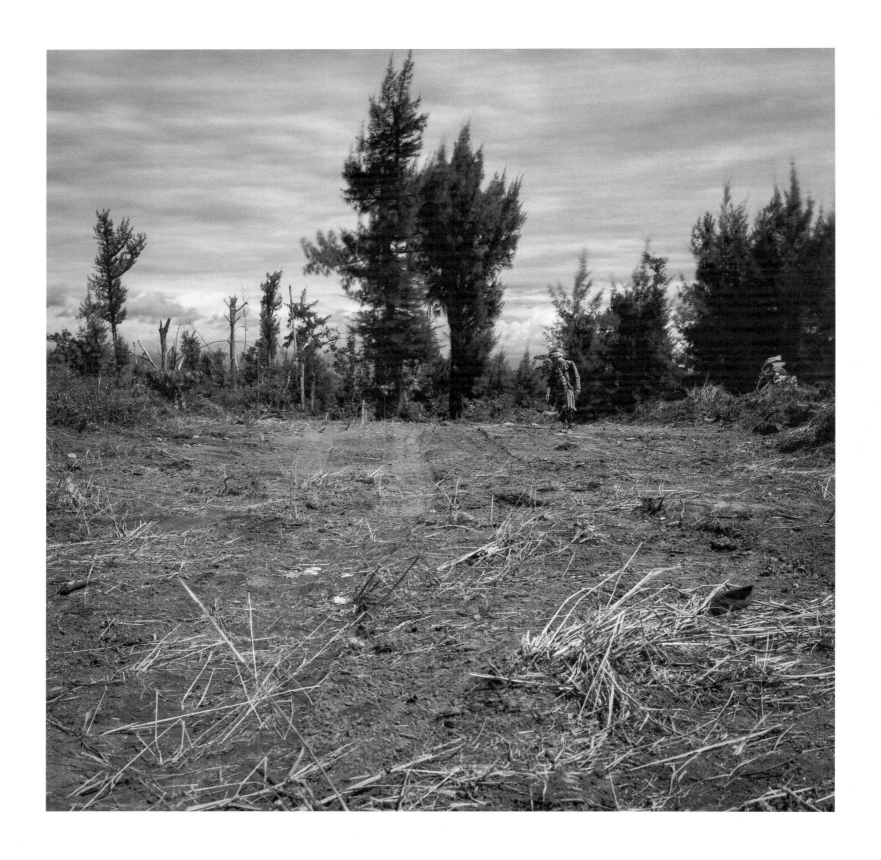

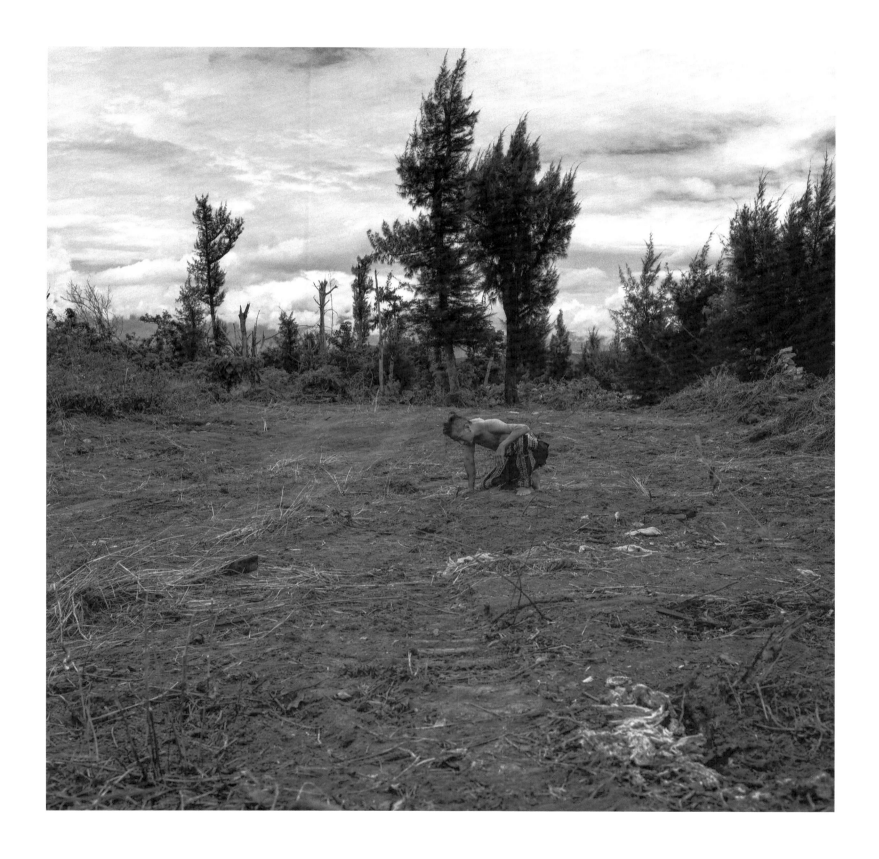

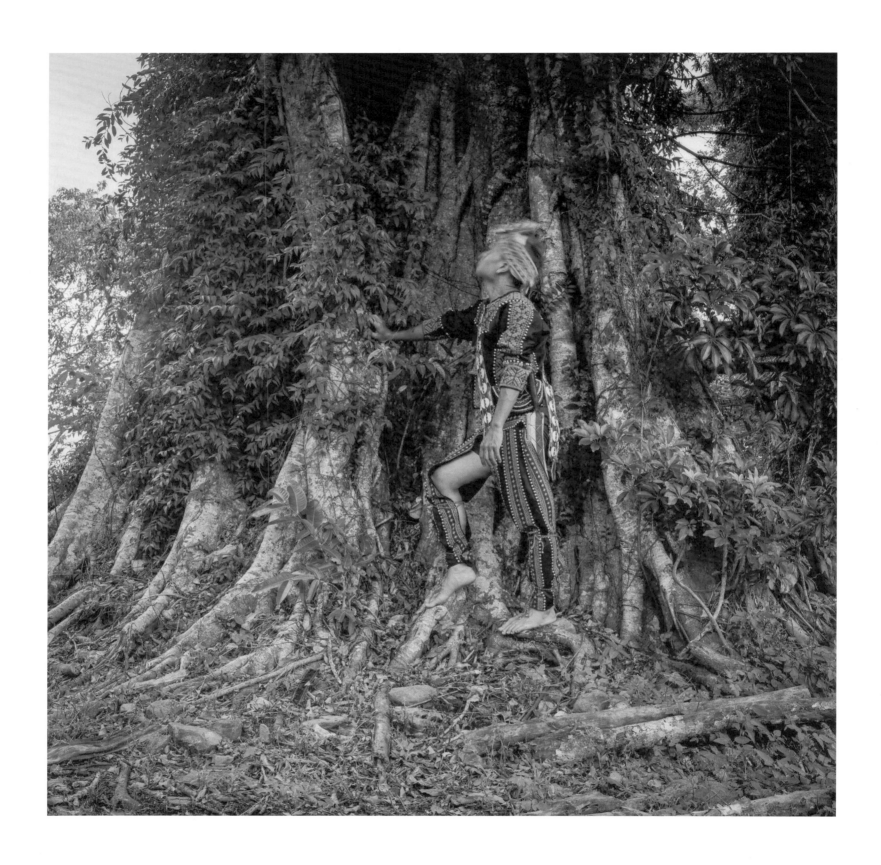

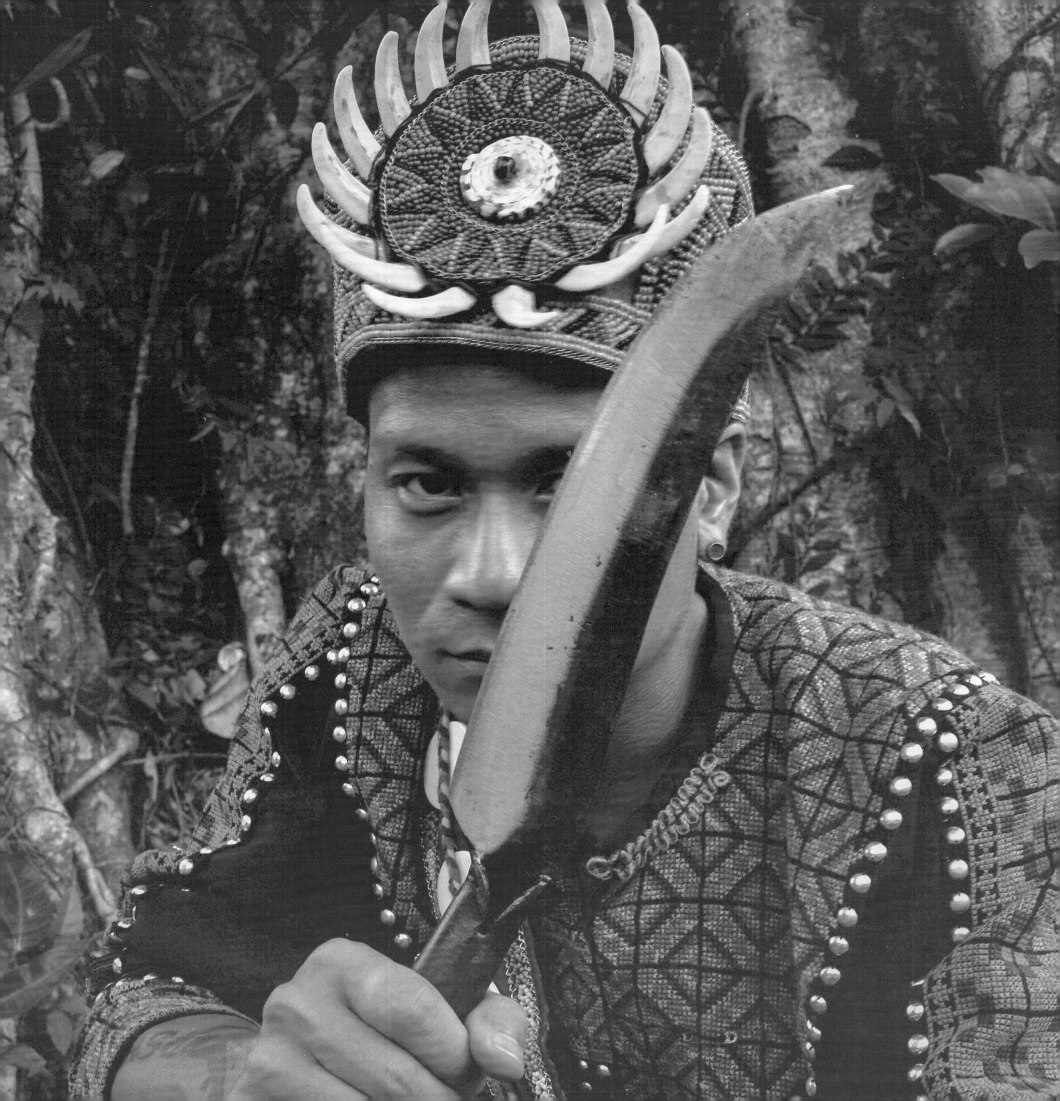

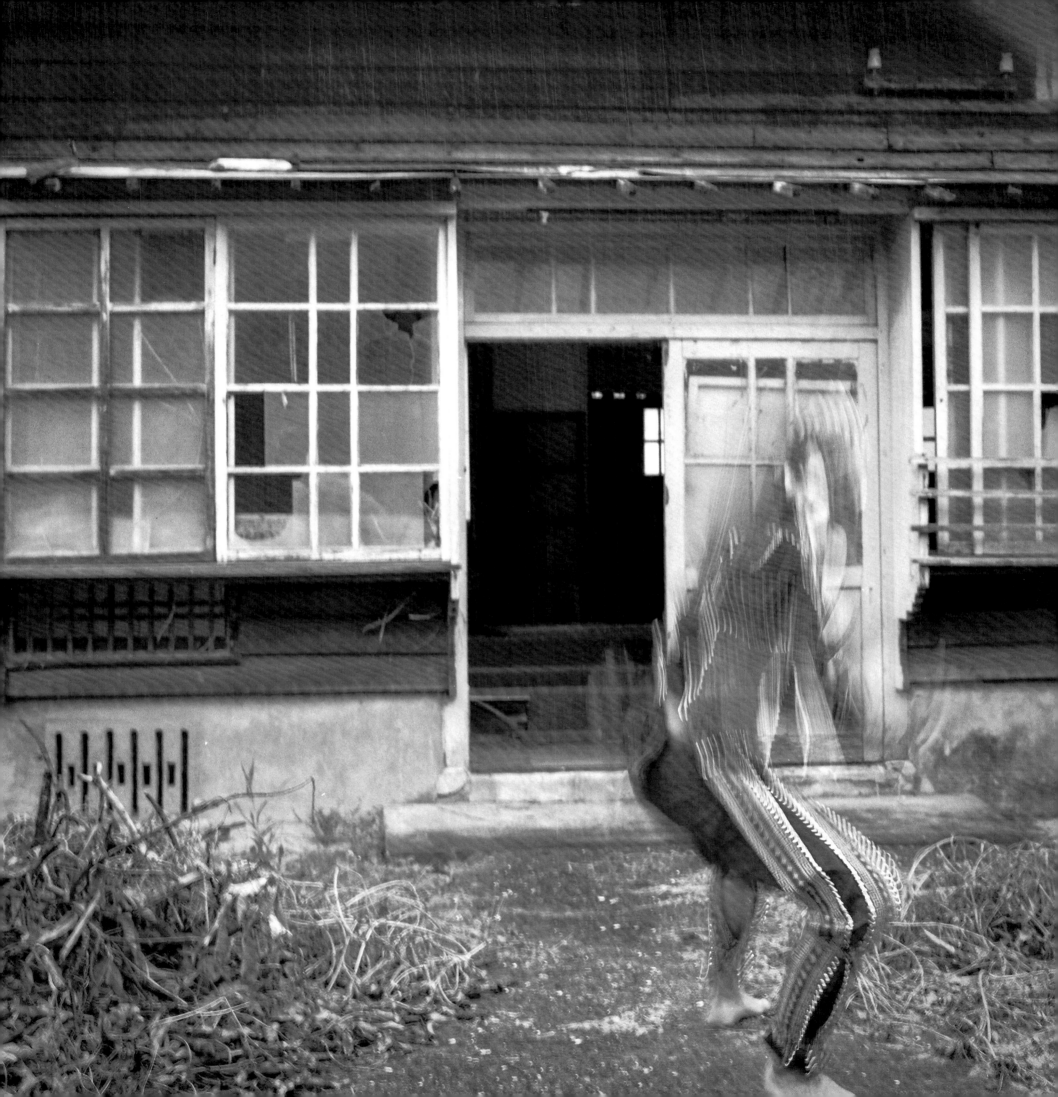

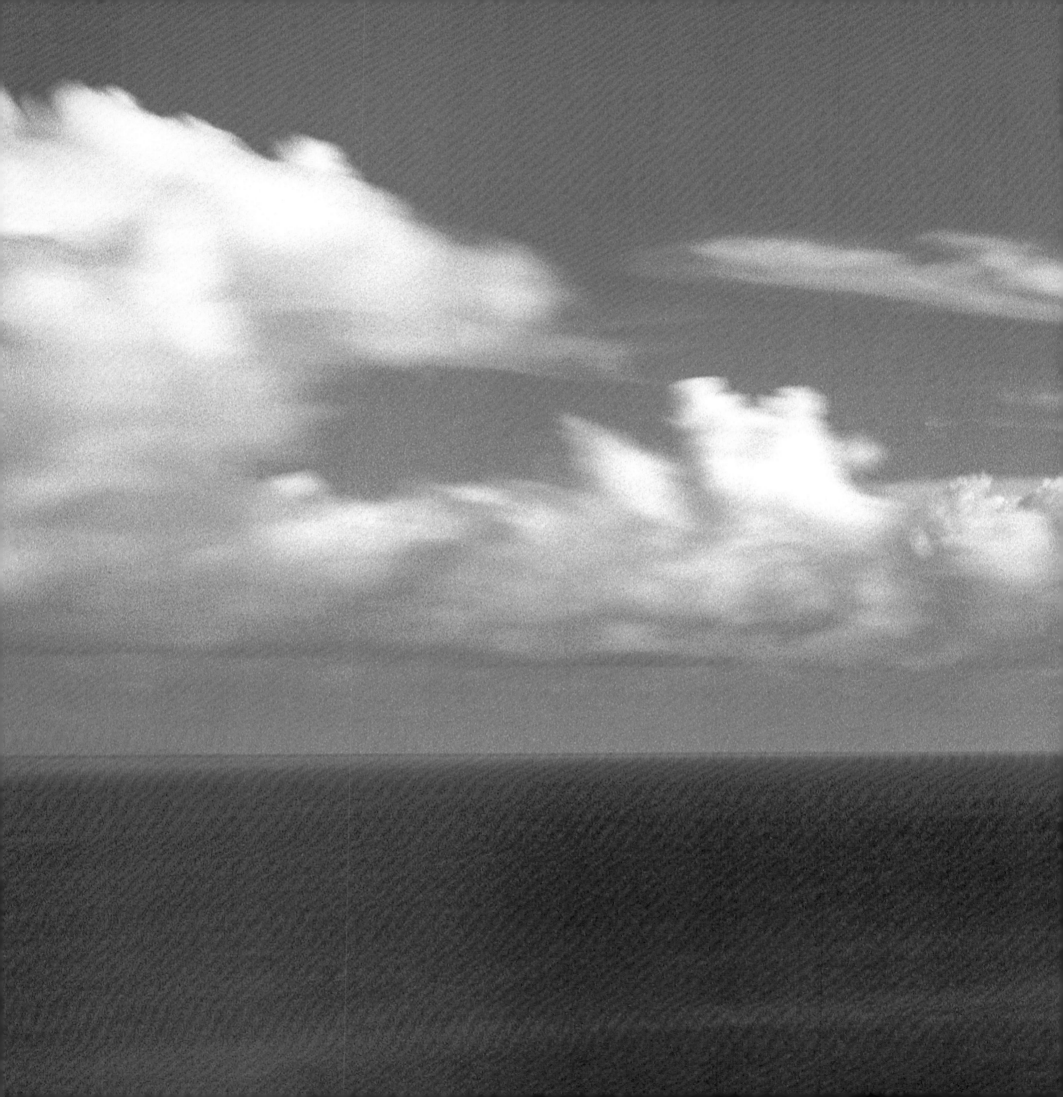

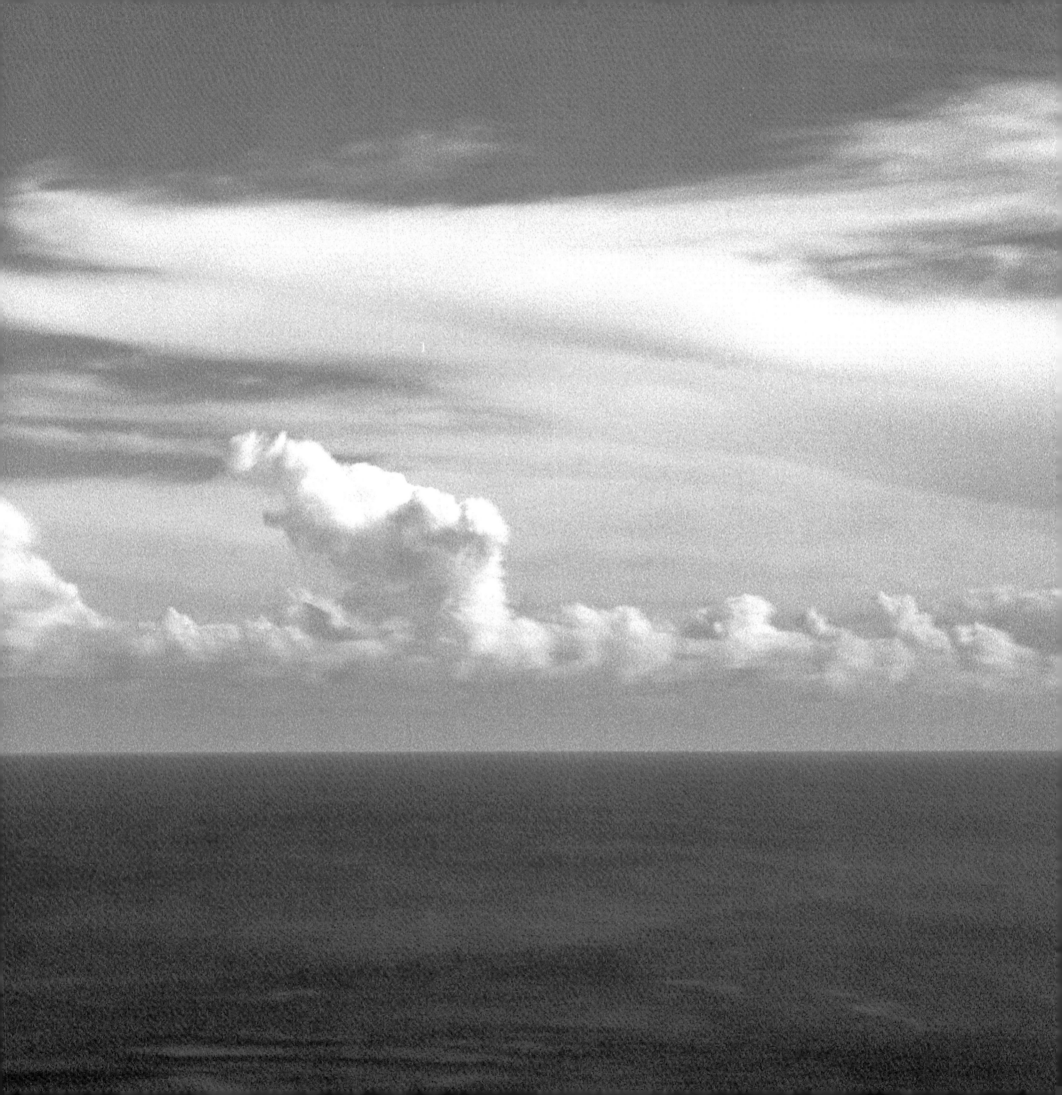

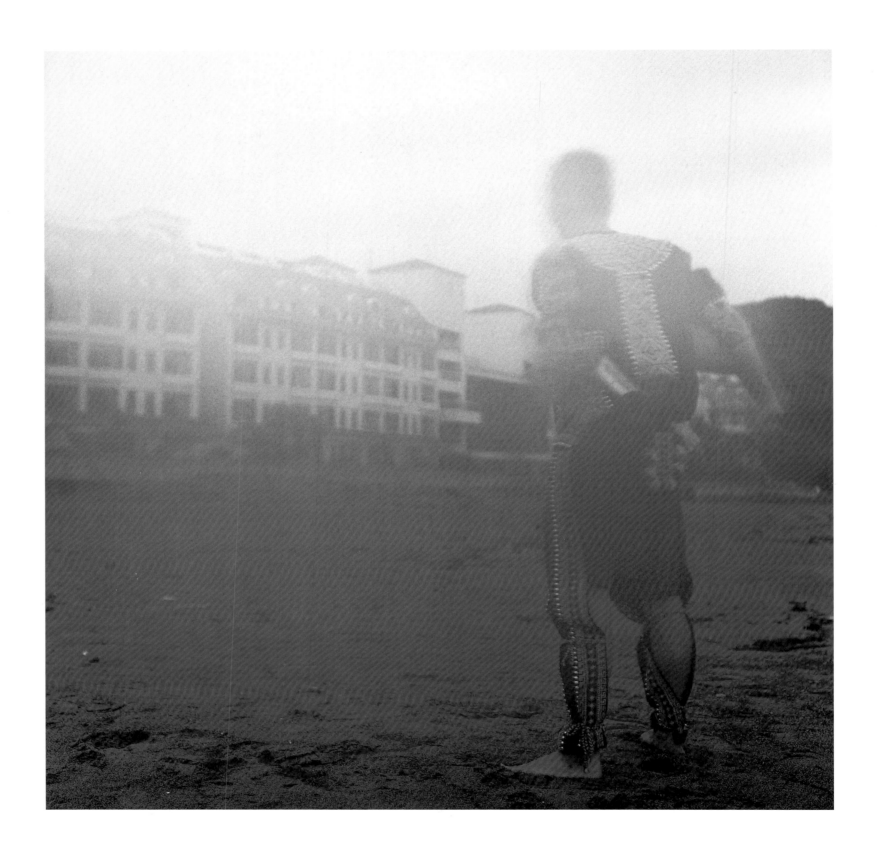

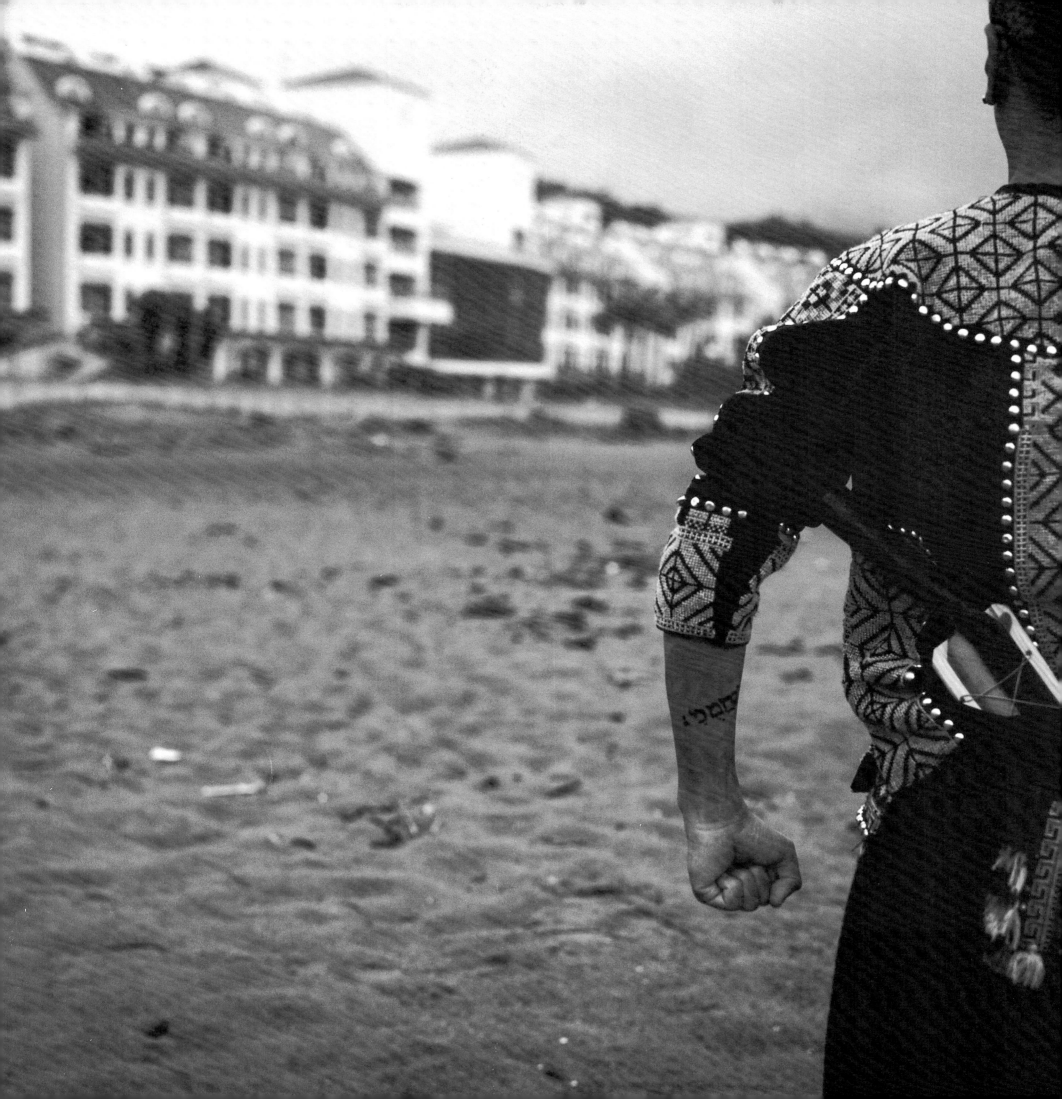

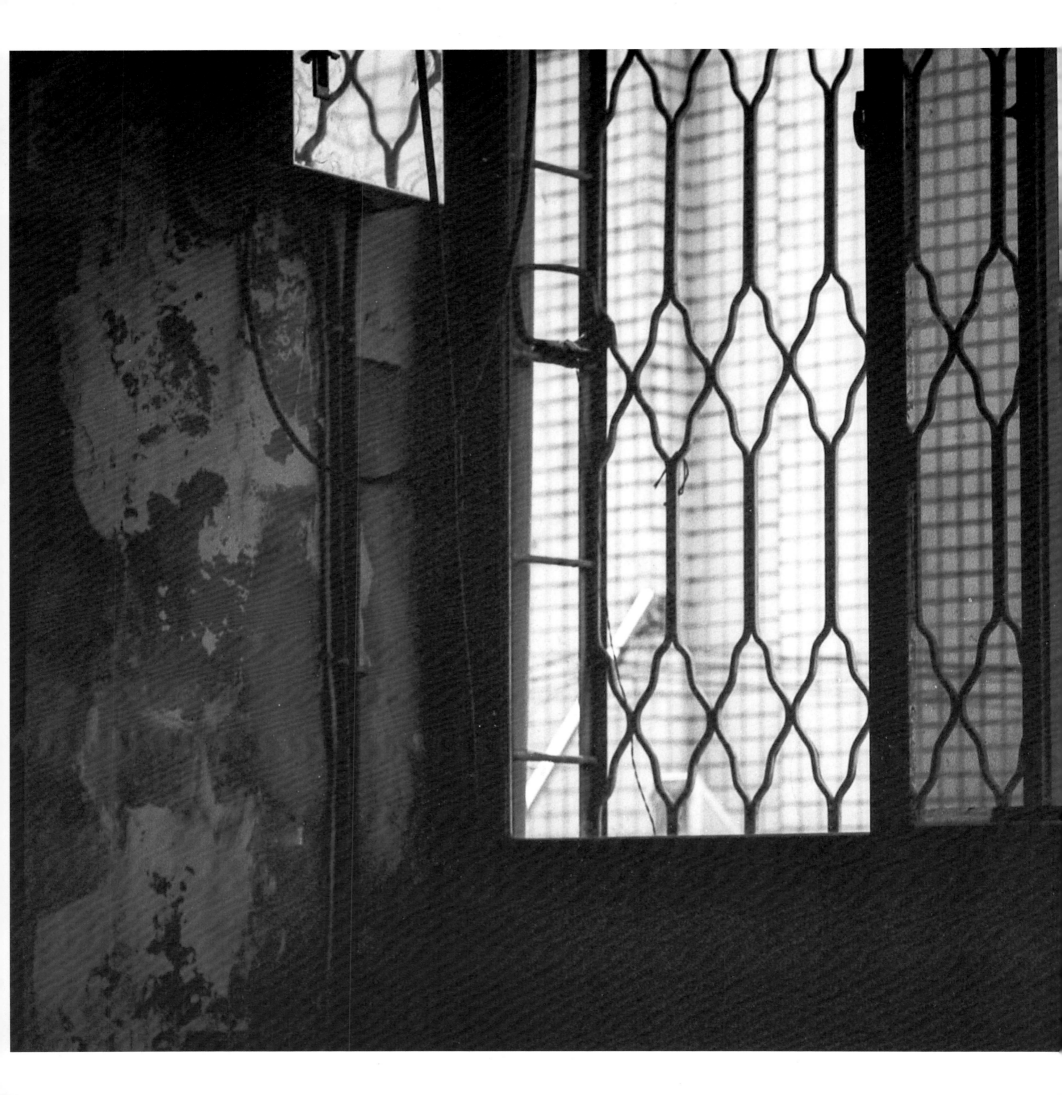

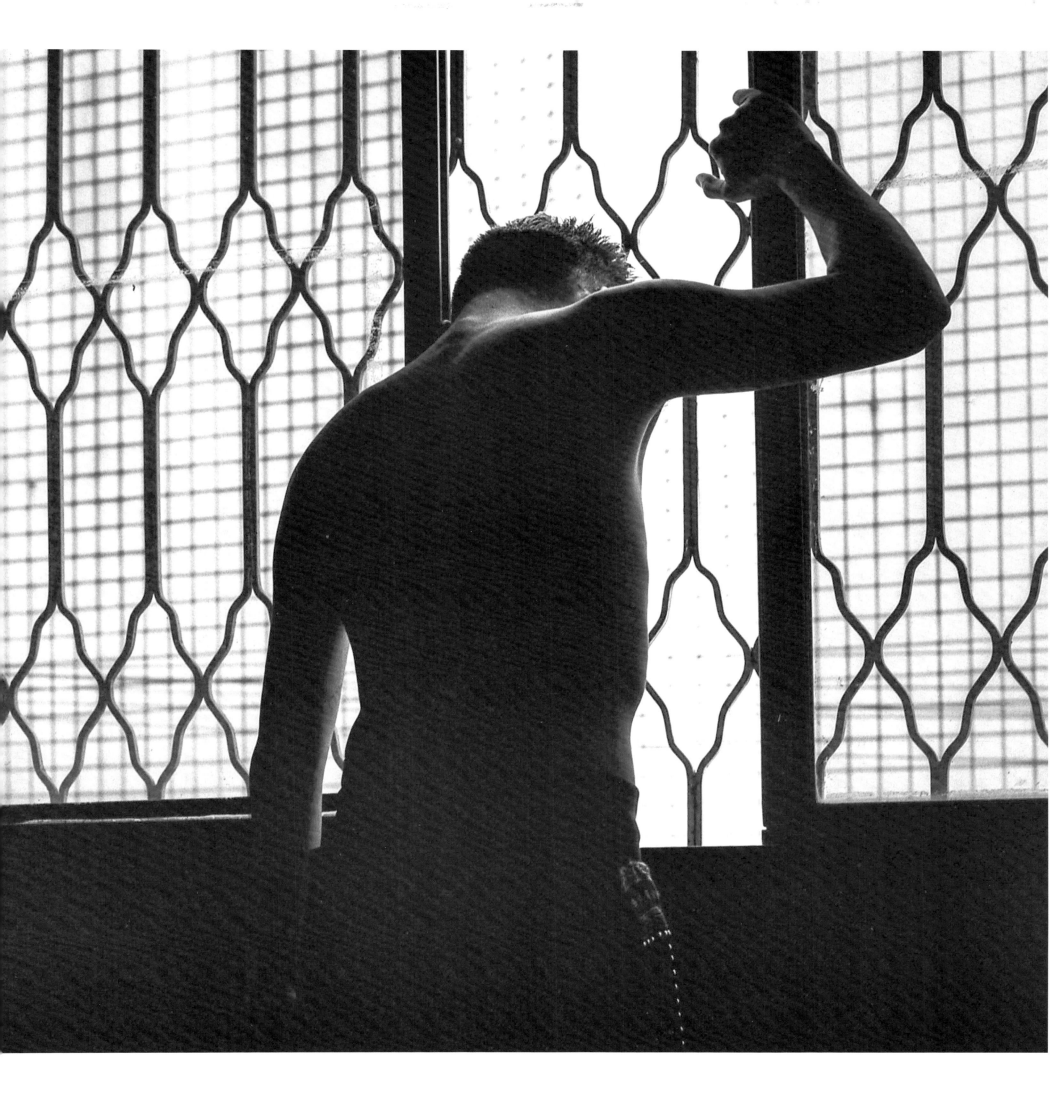

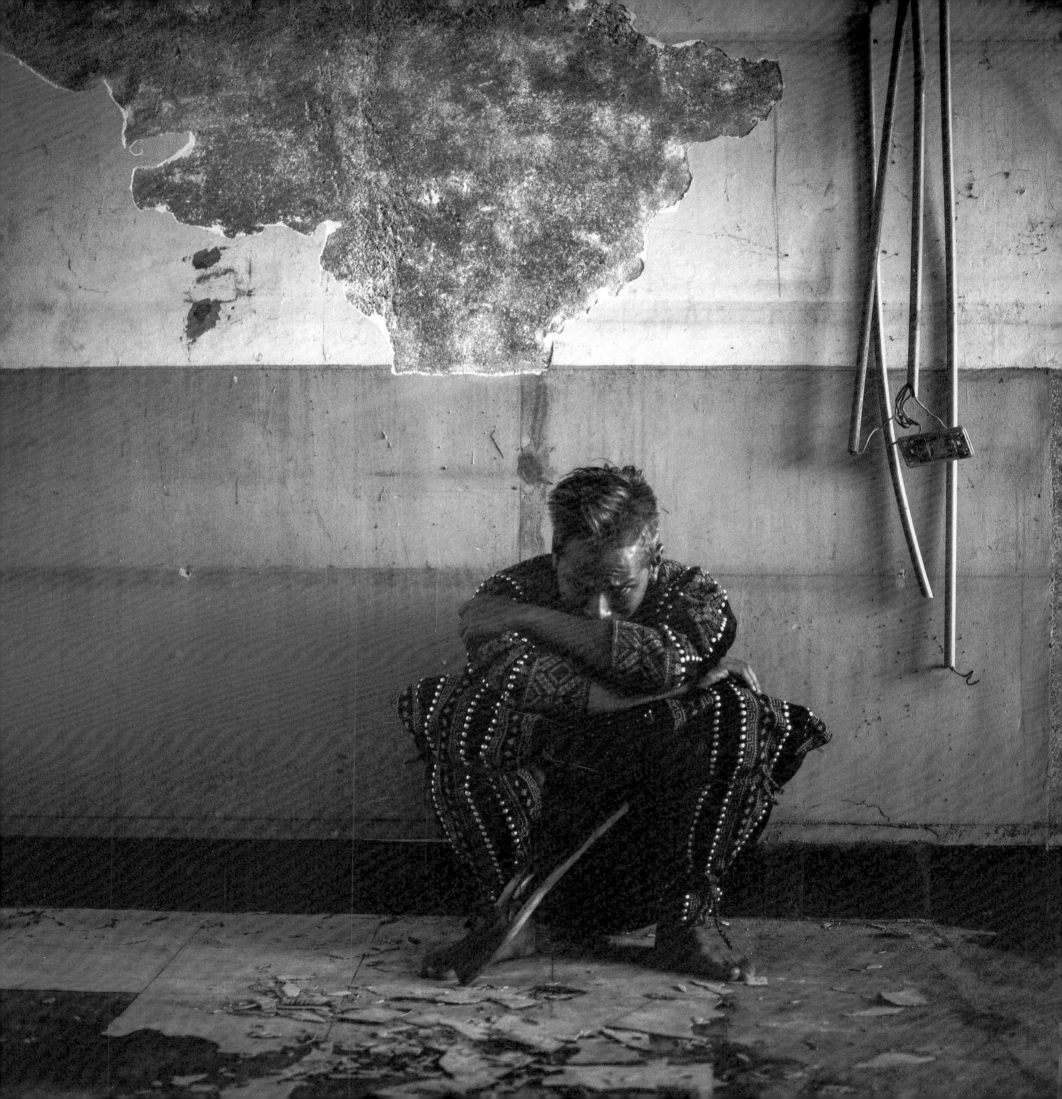

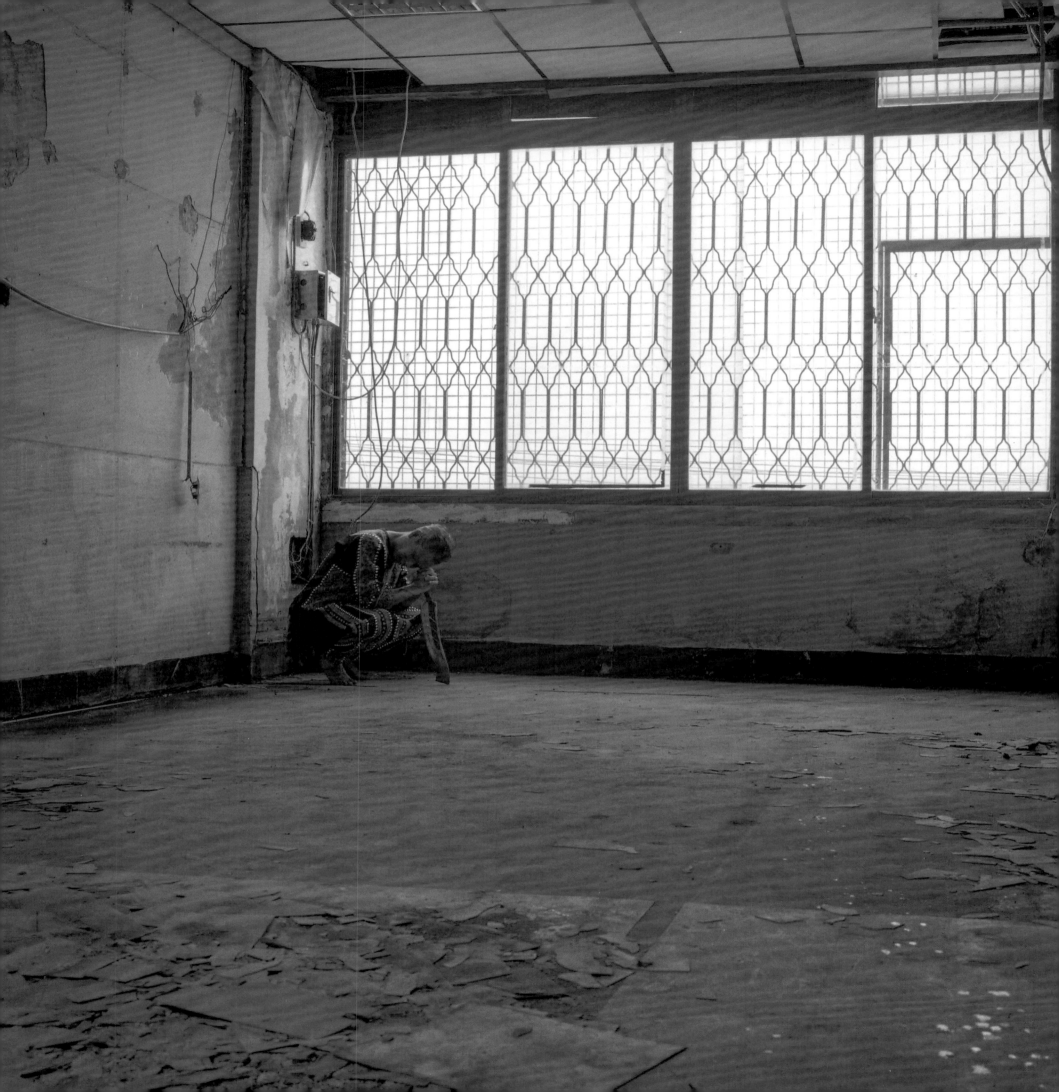

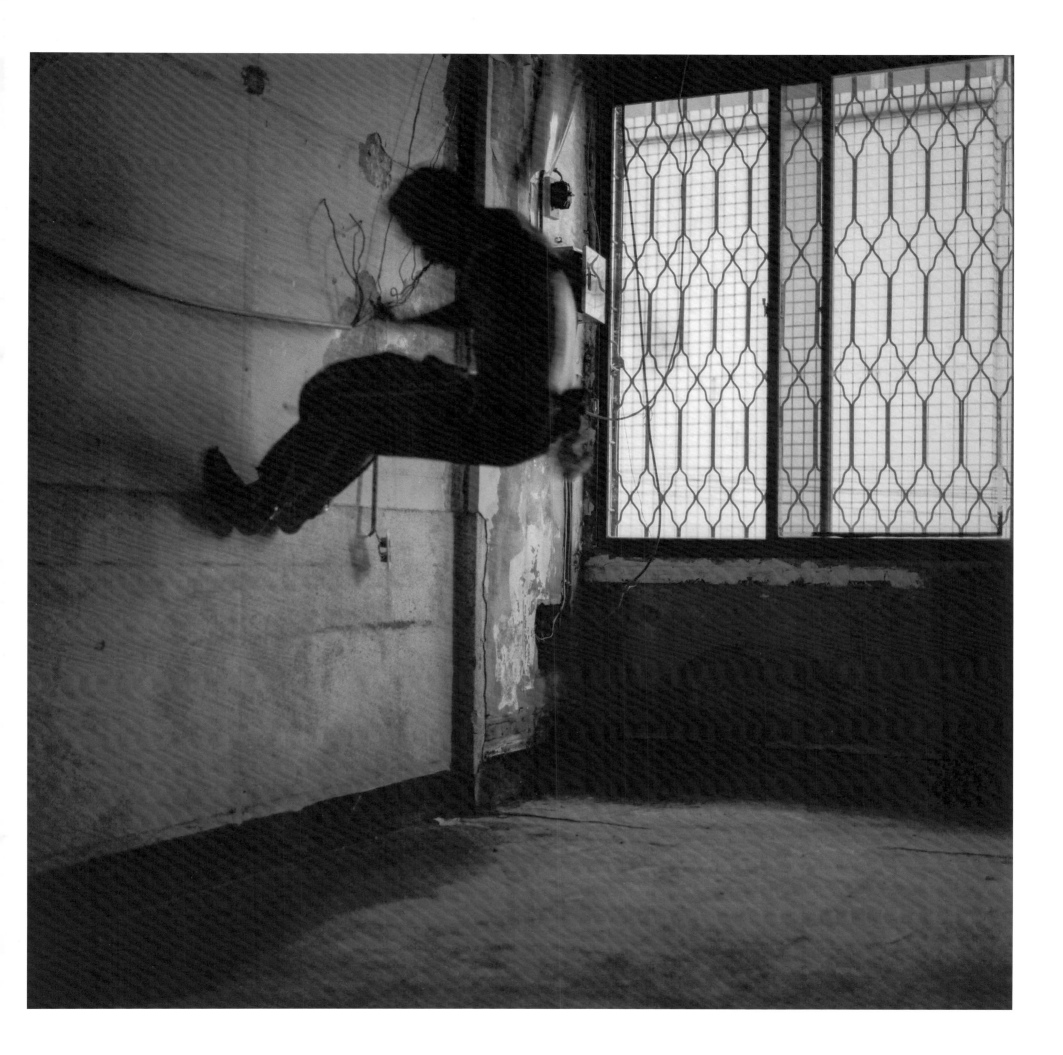

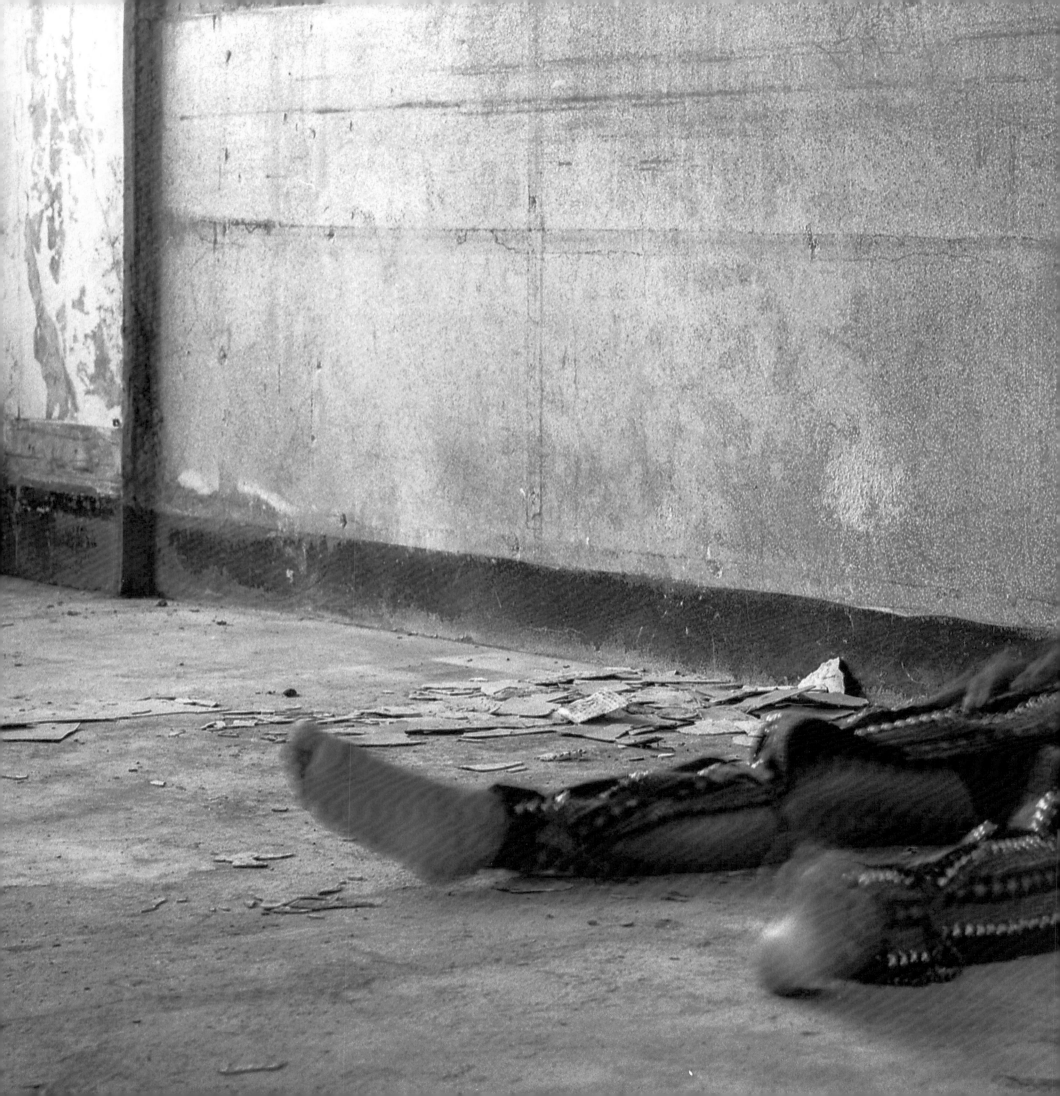

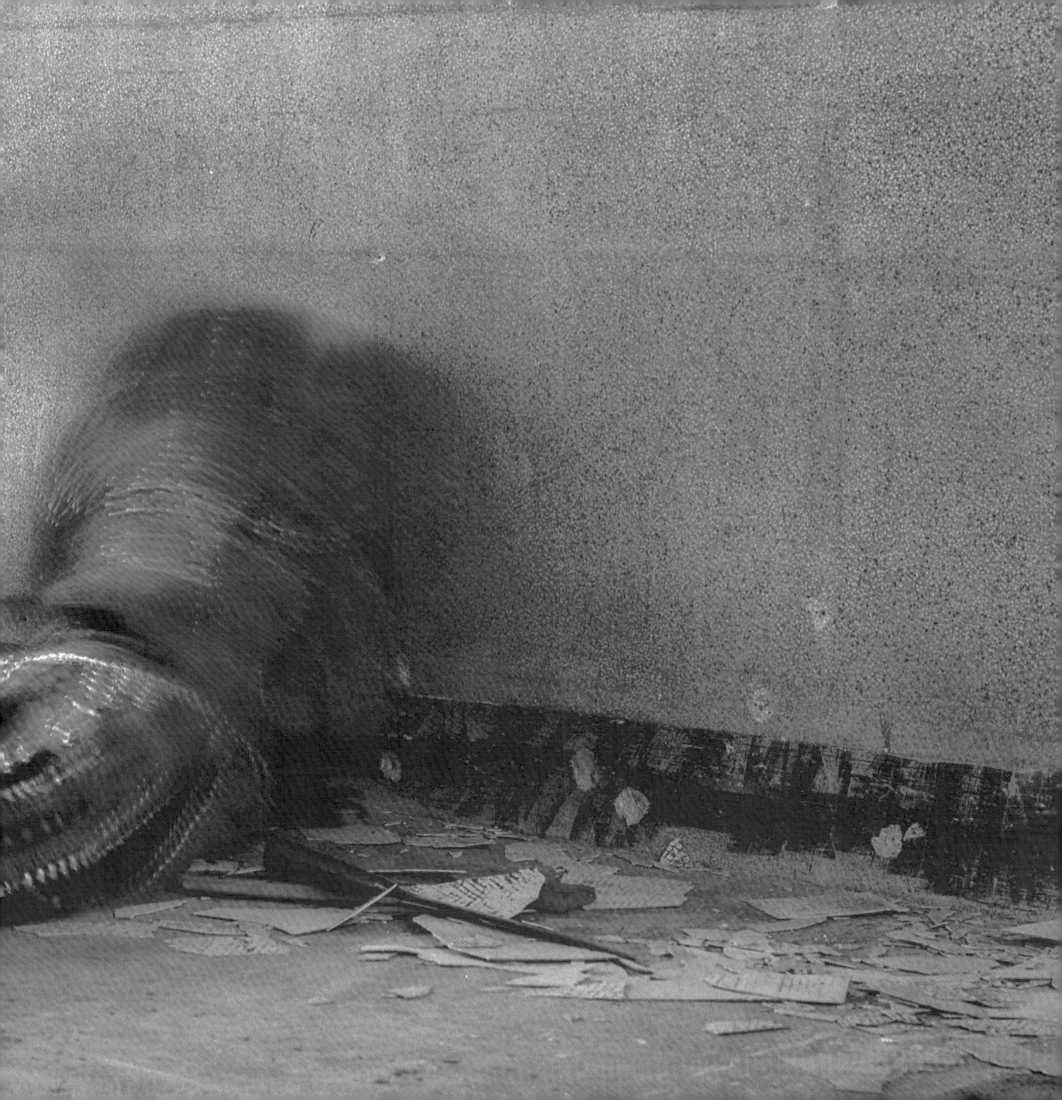

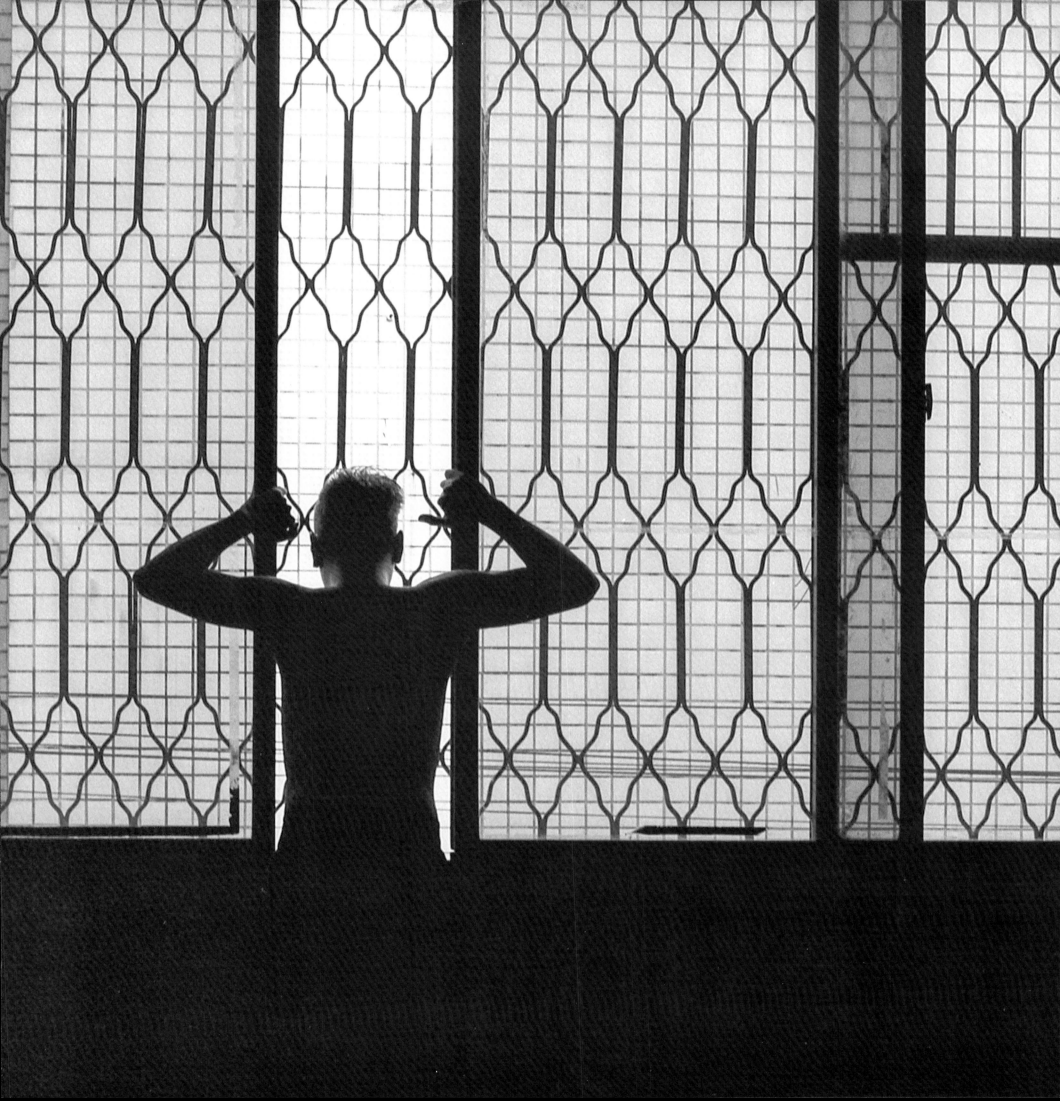

Formosa Aborigines

福爾摩沙的守護者

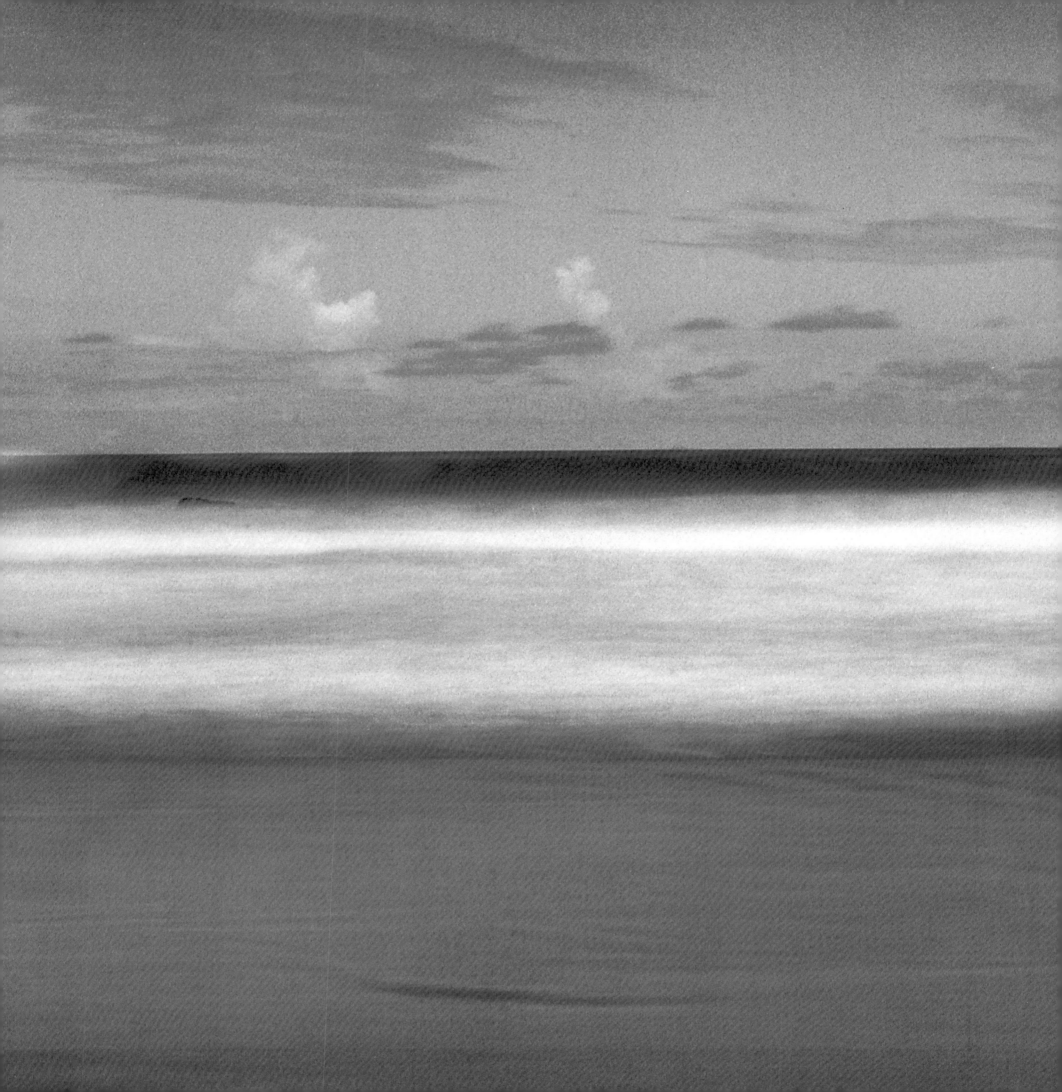

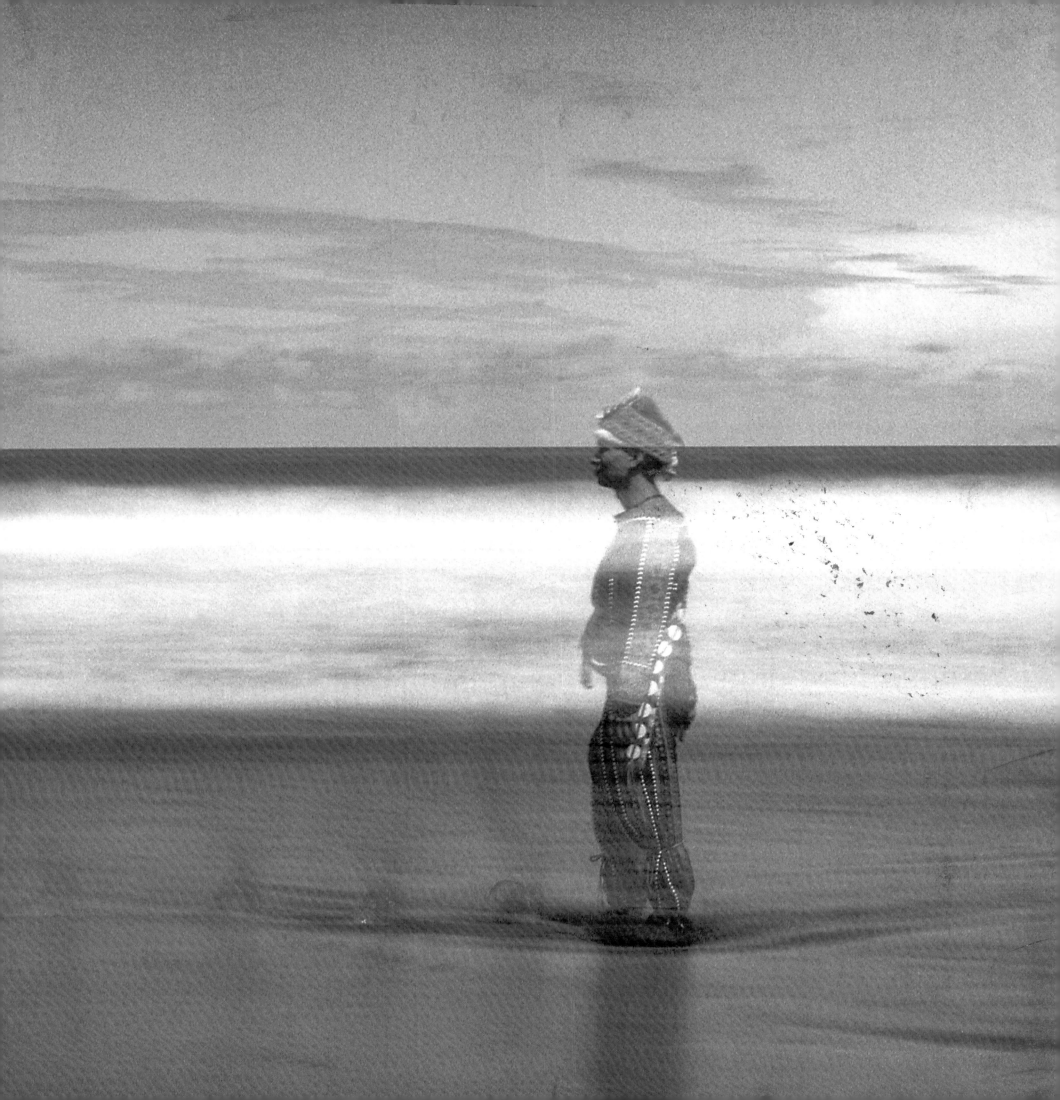

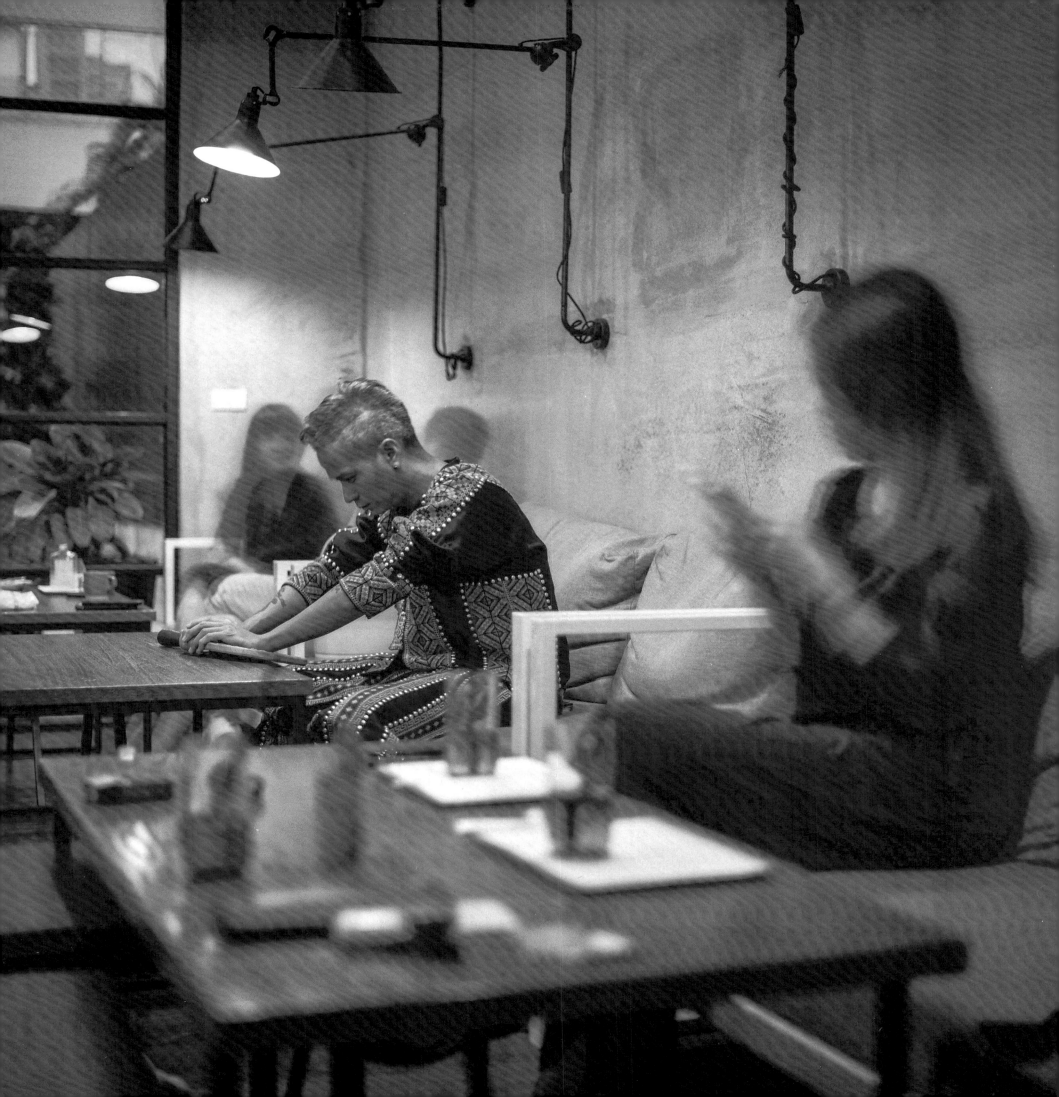

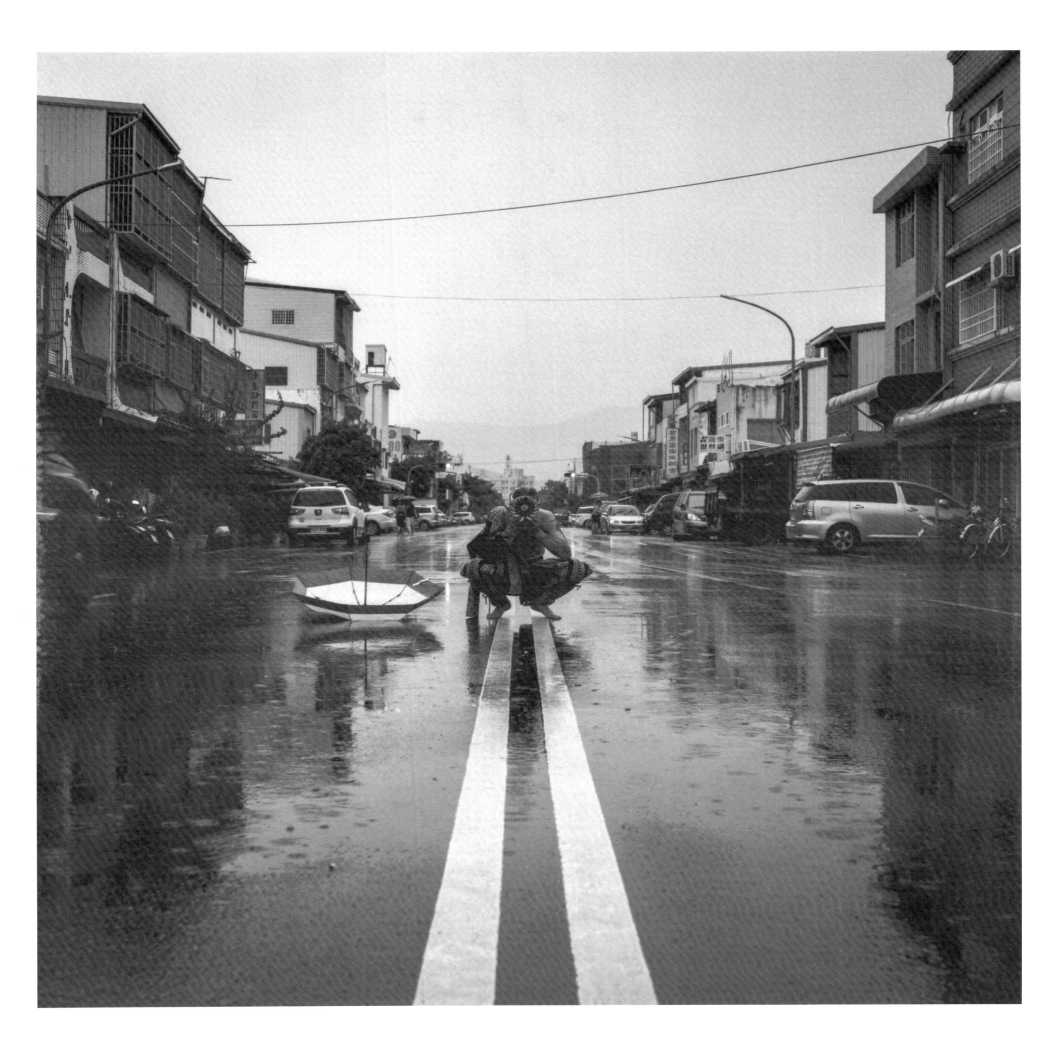

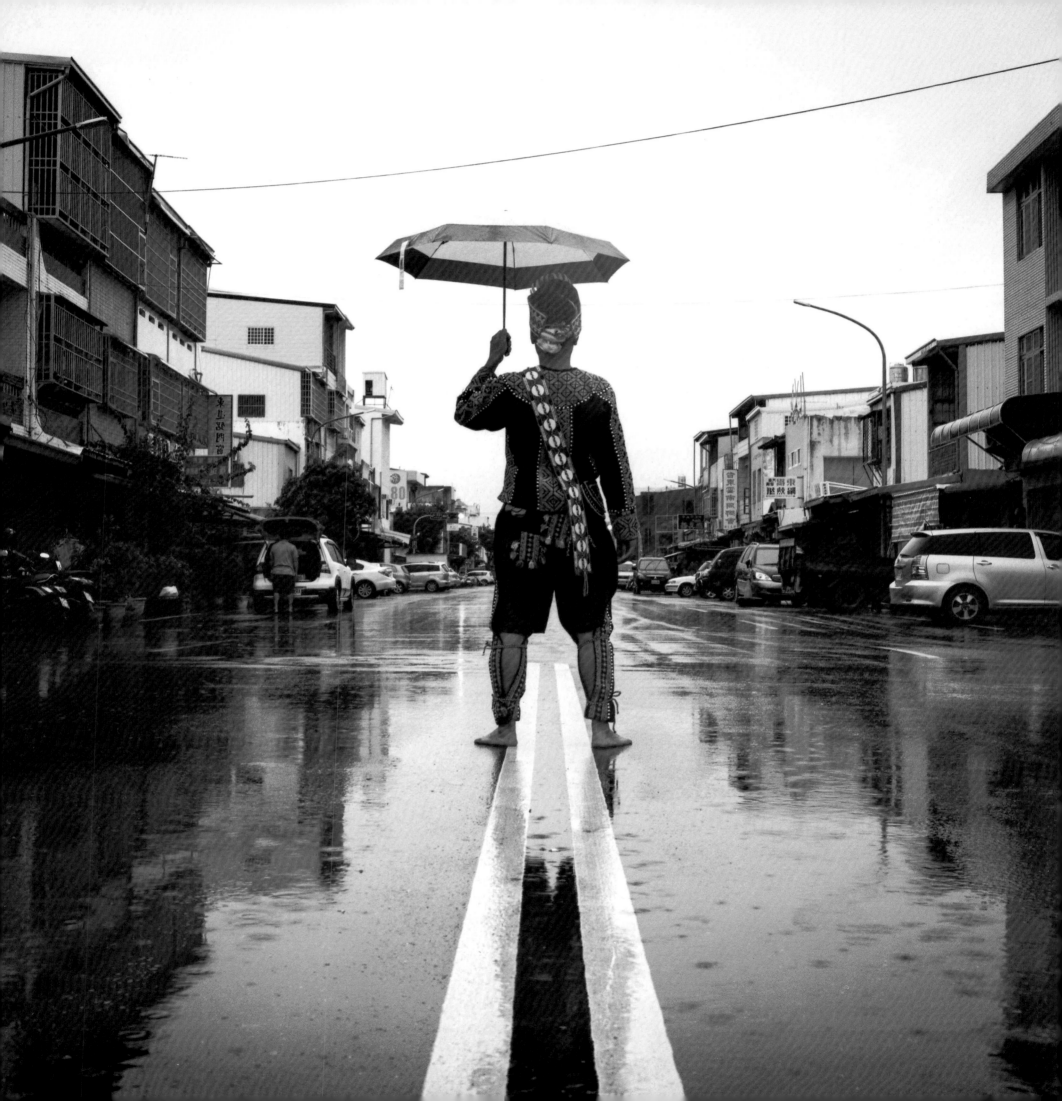

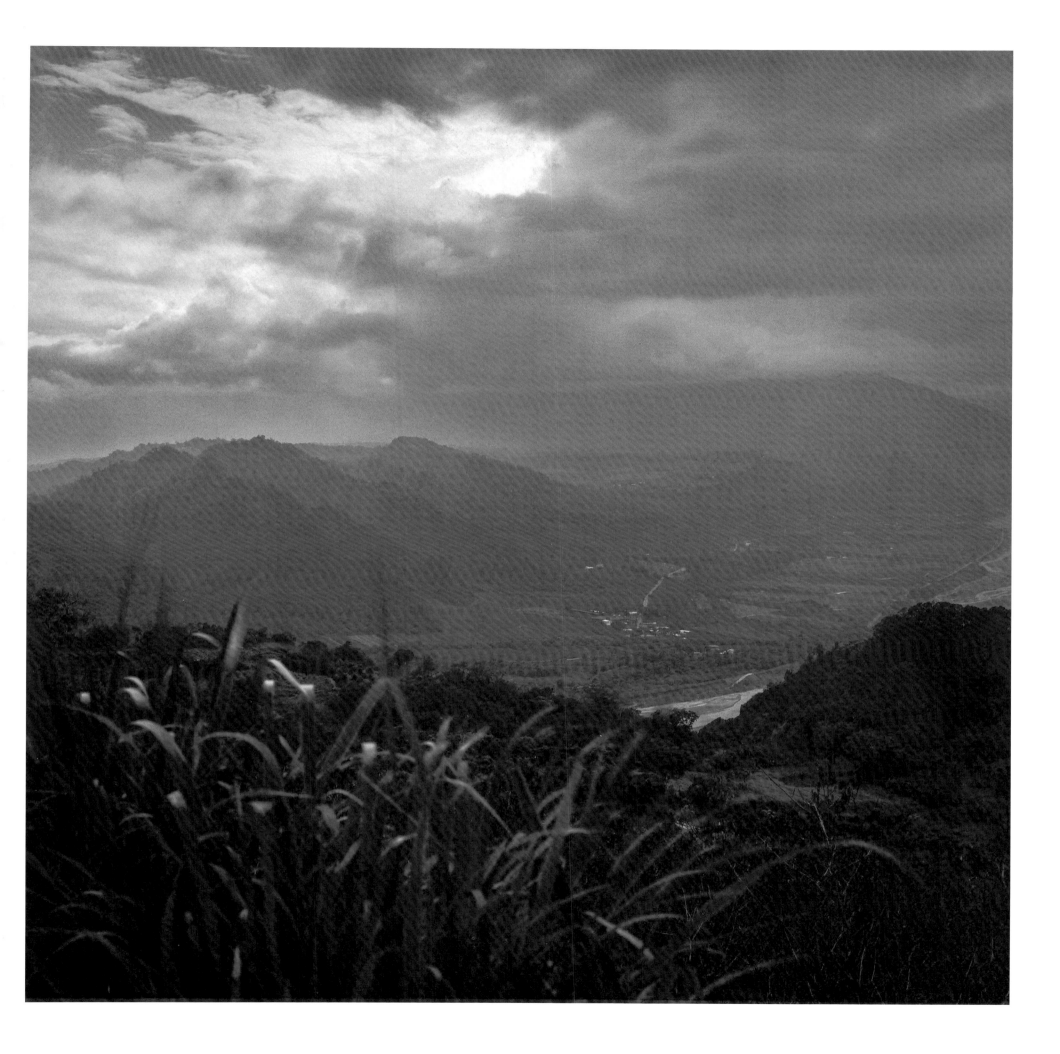

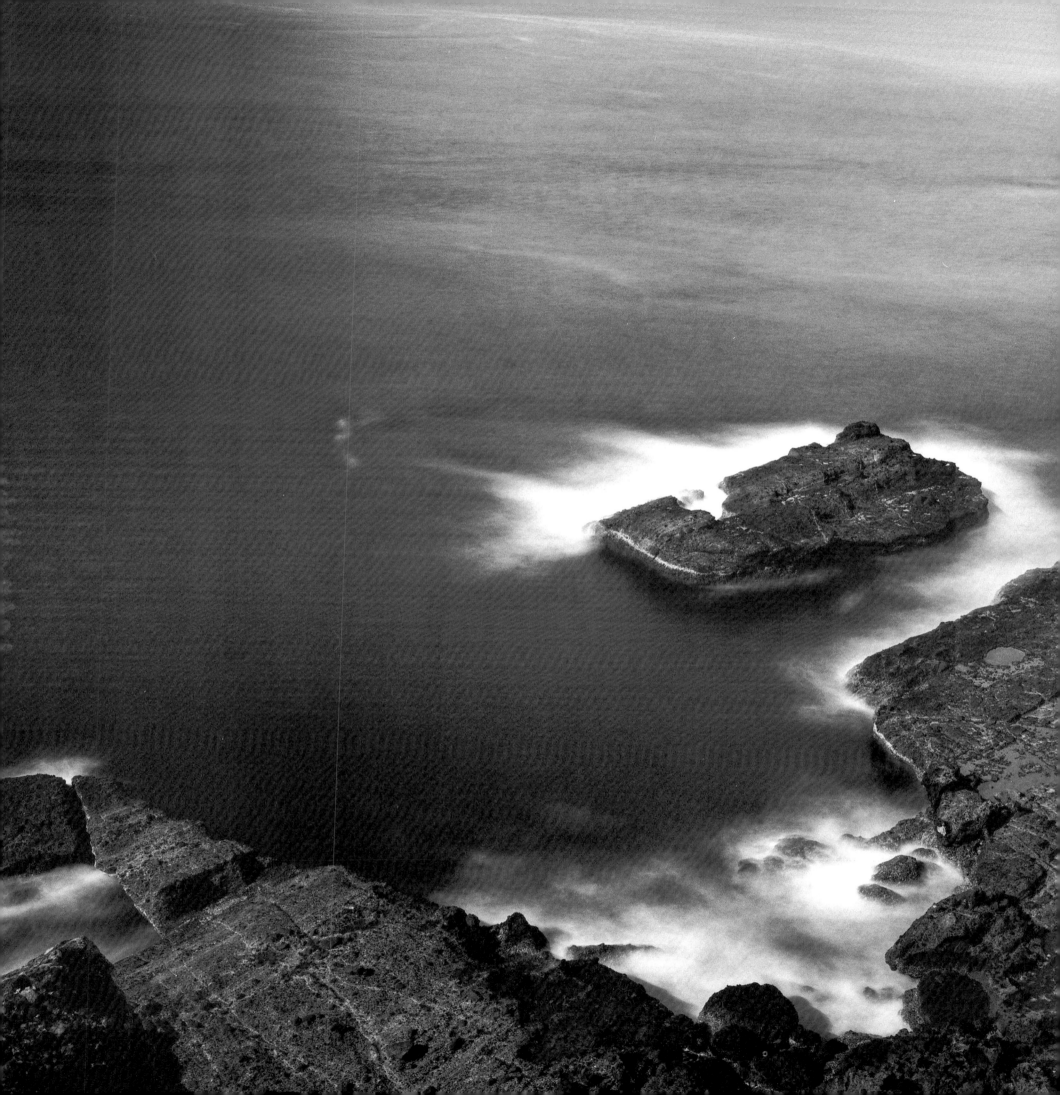

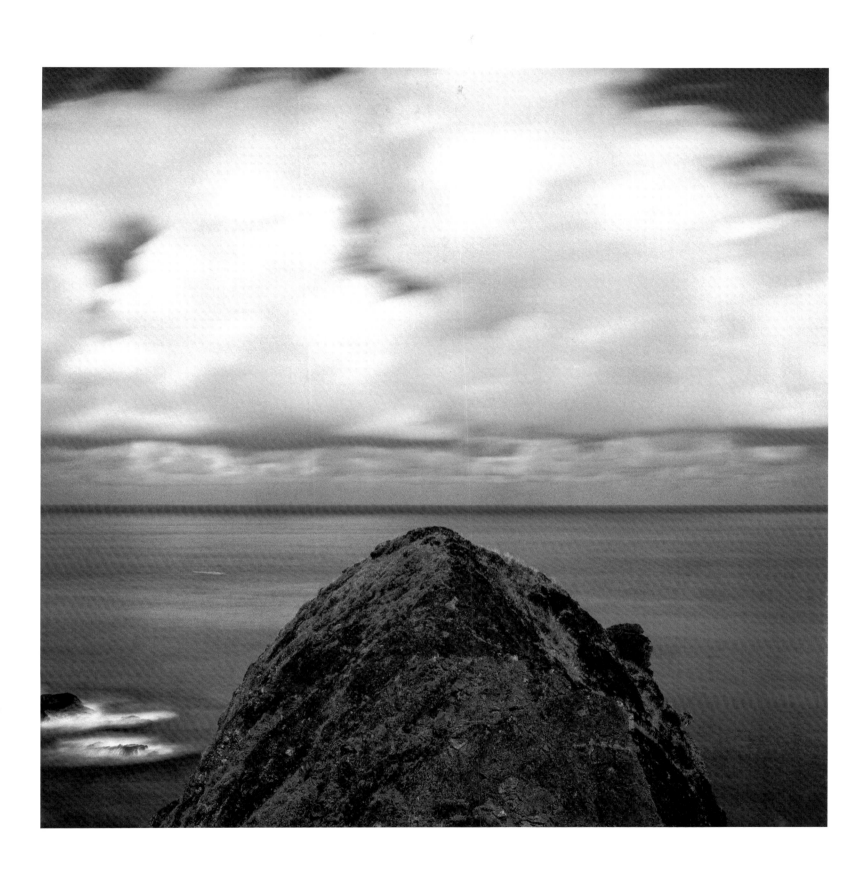

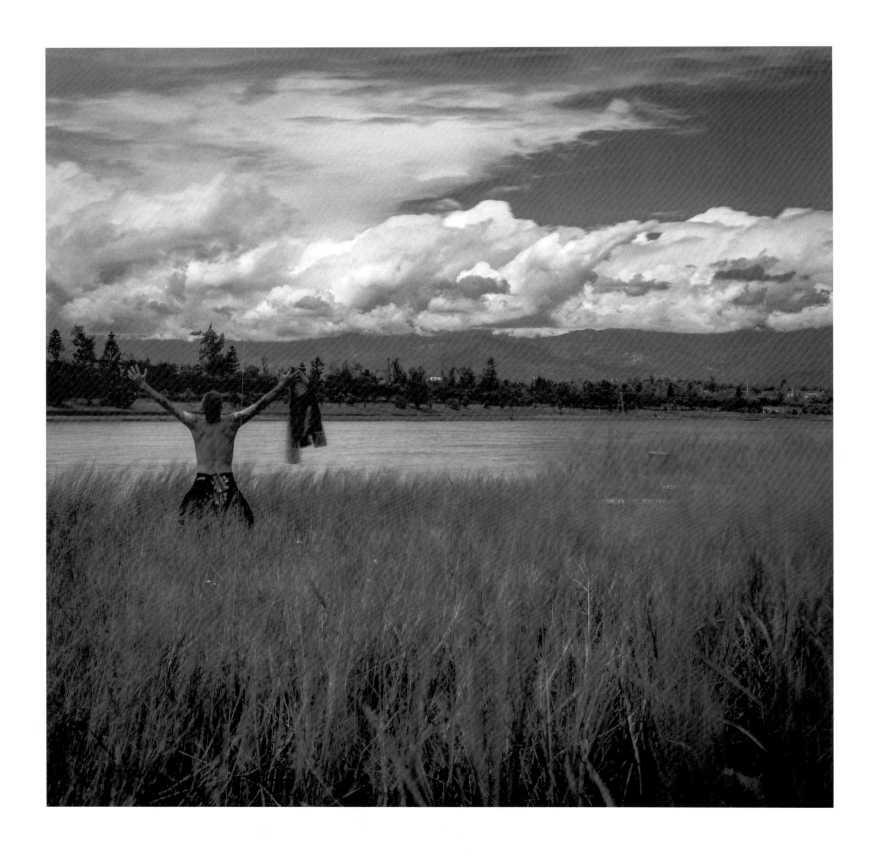

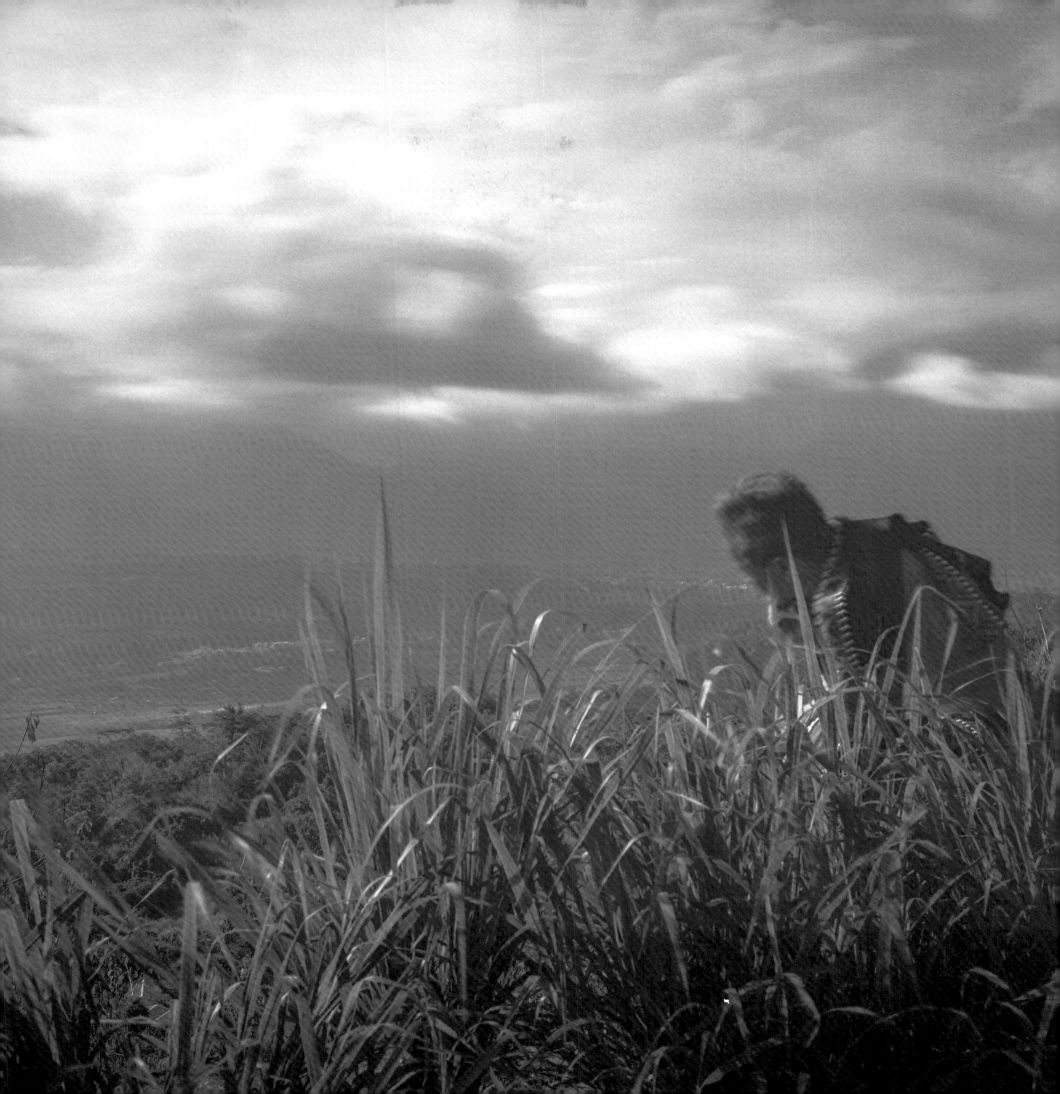

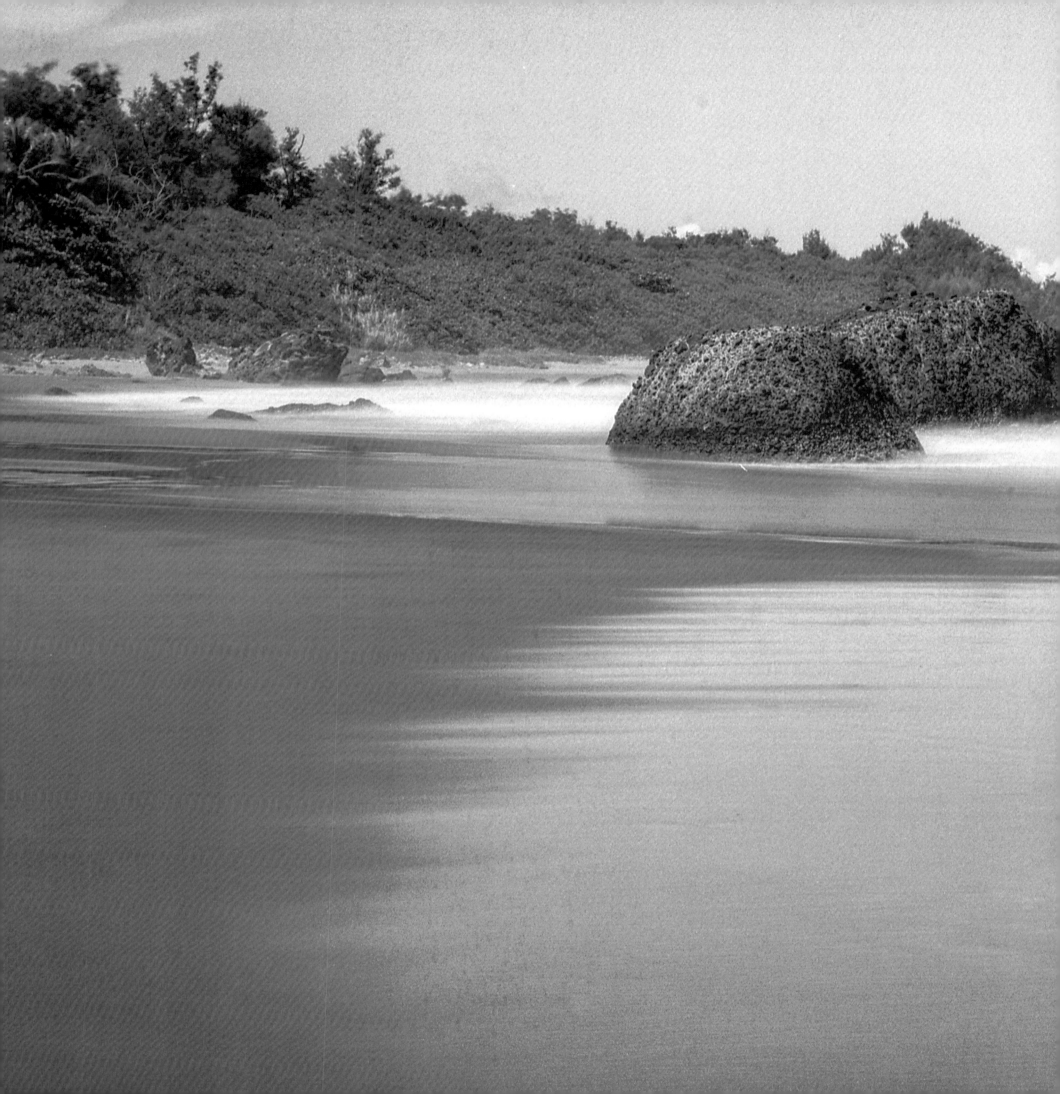

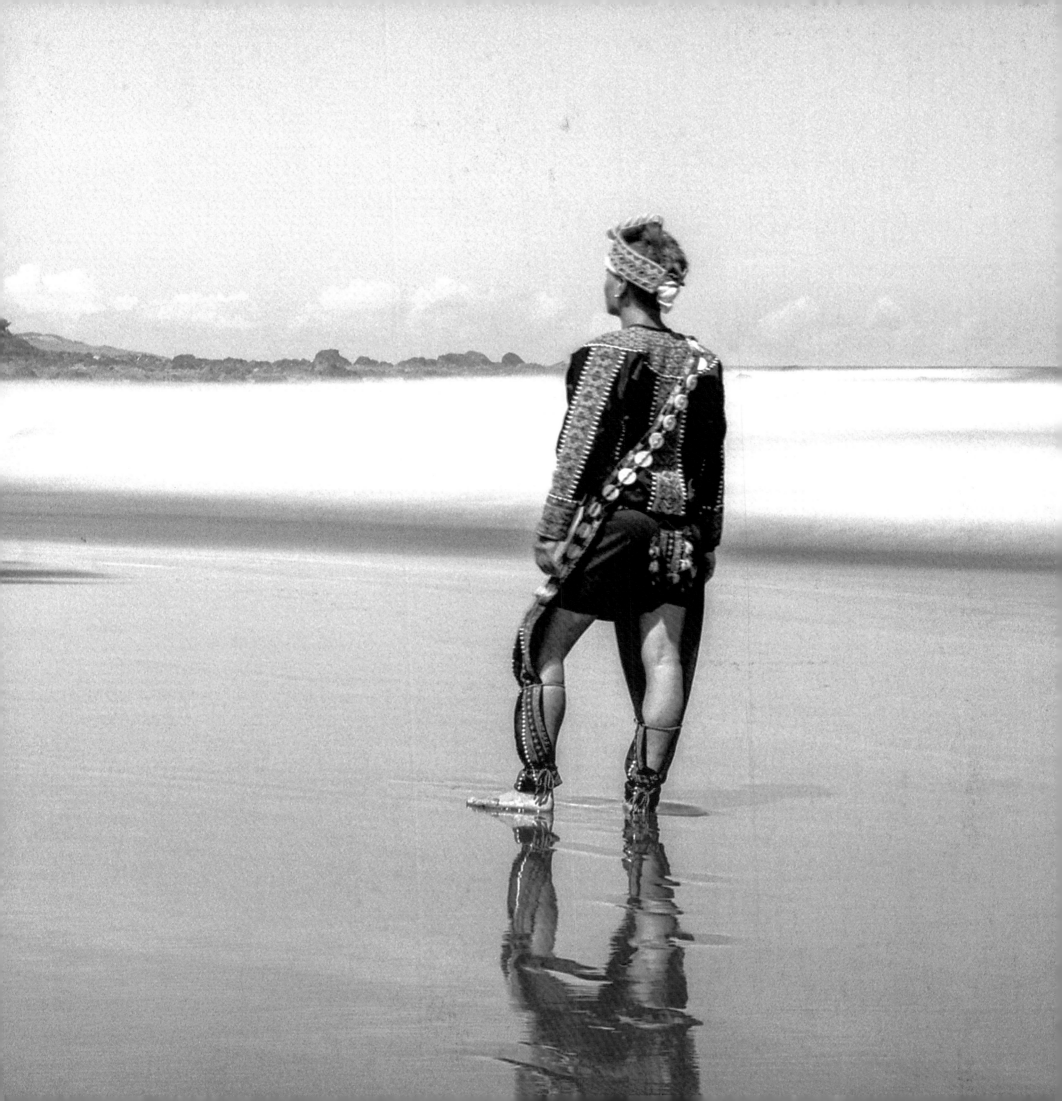

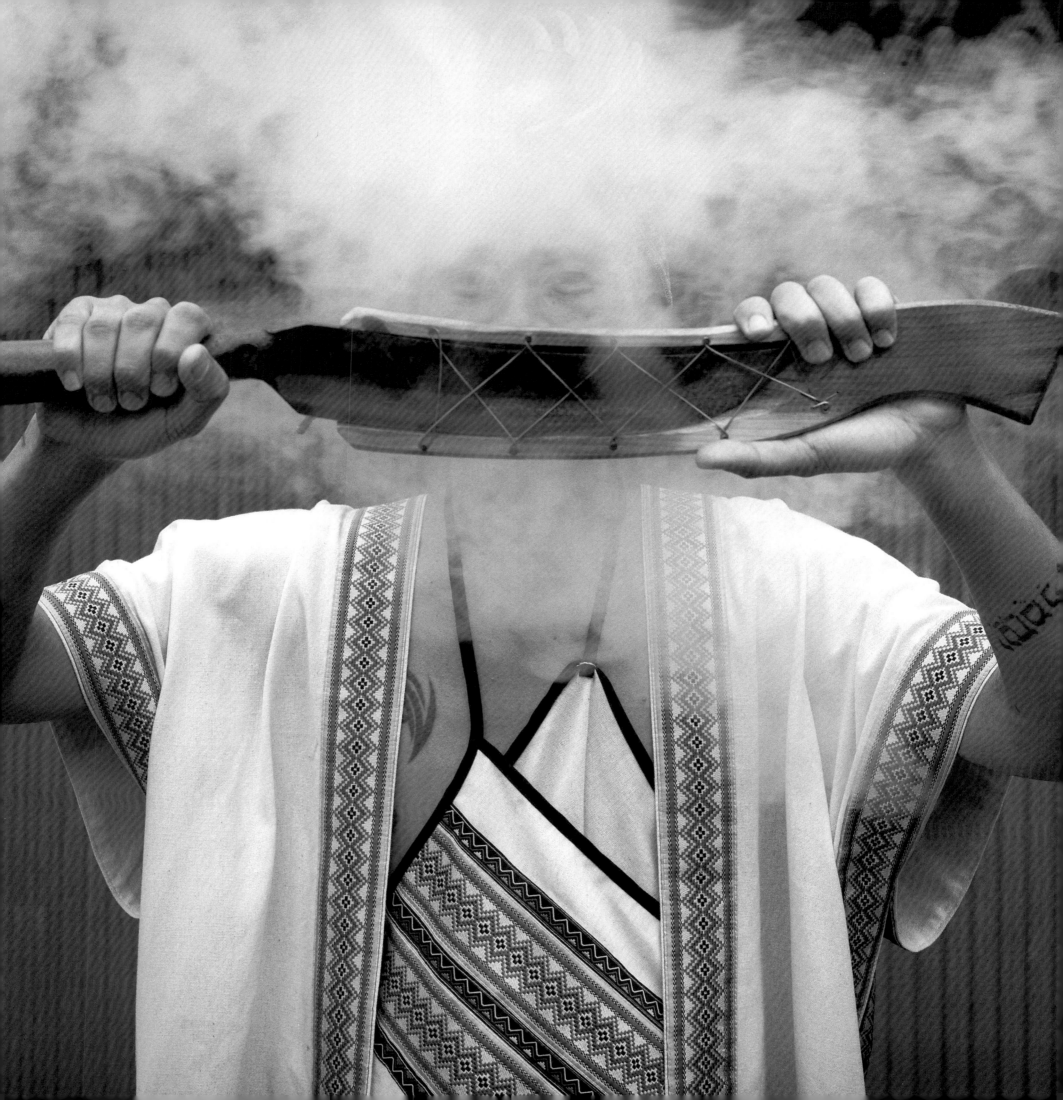

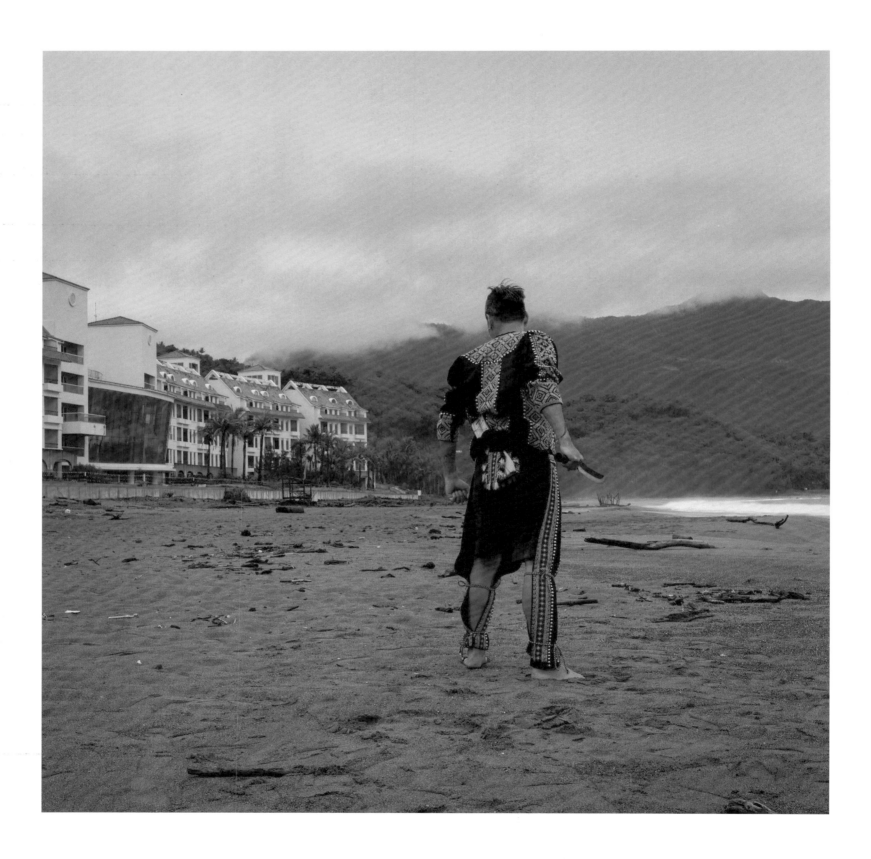

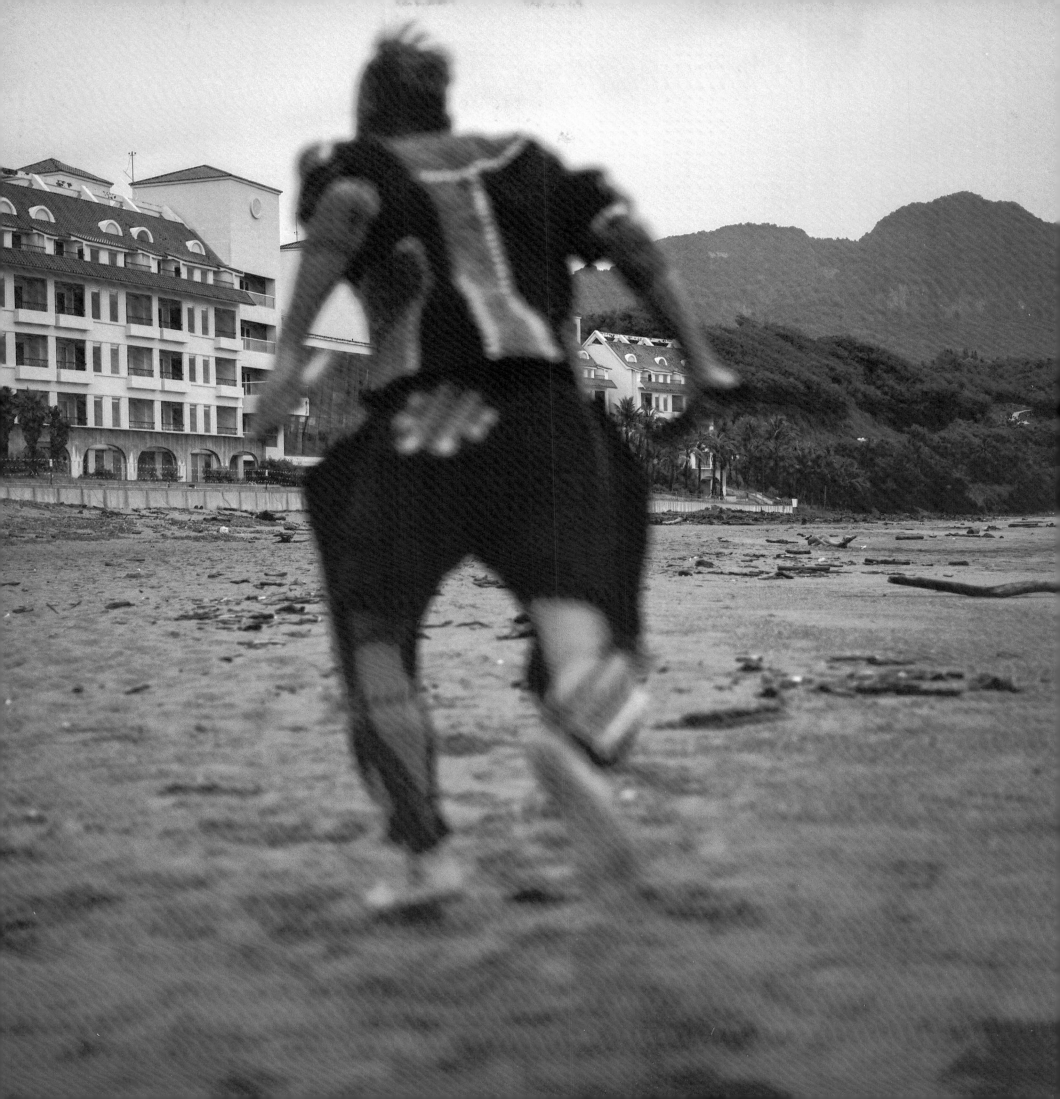

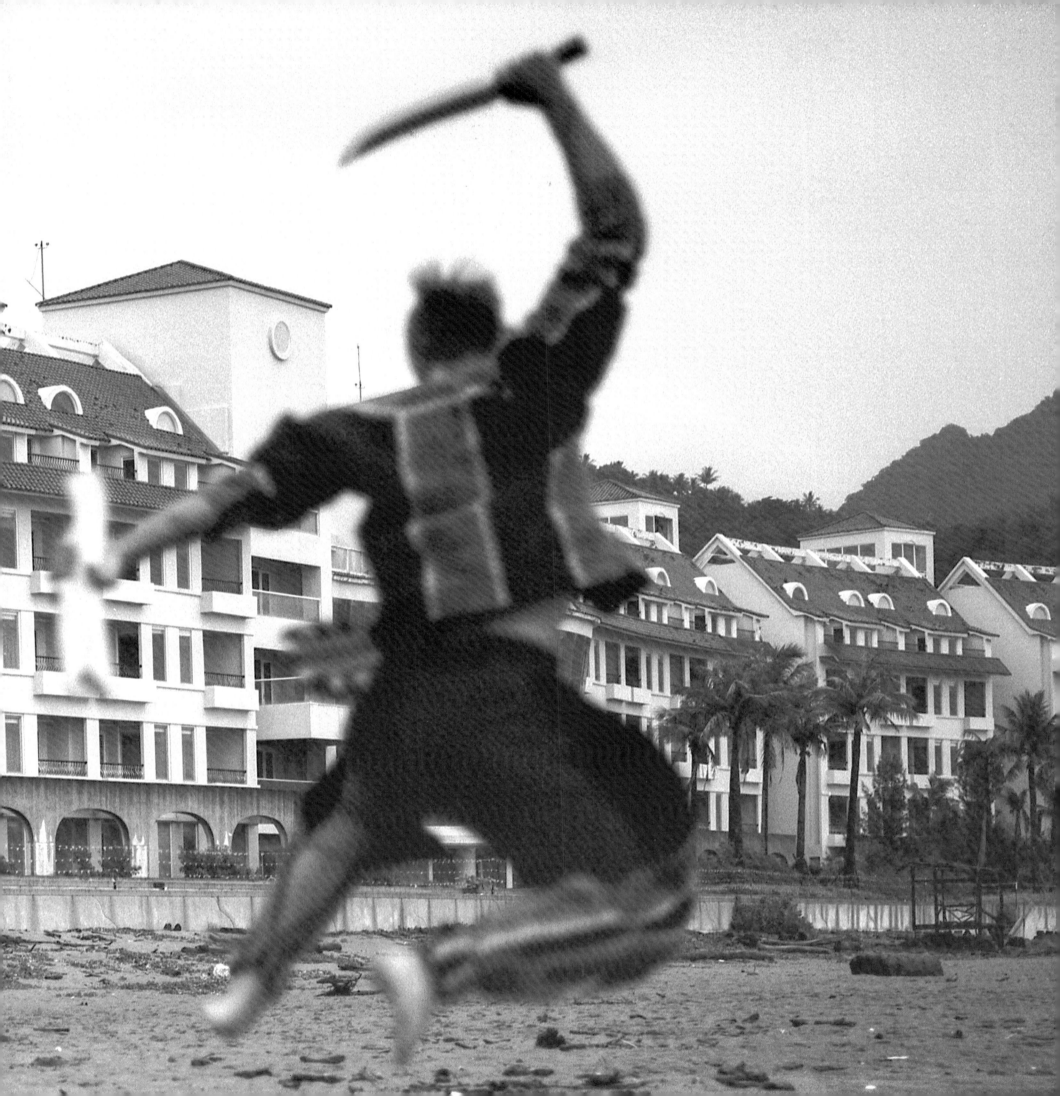

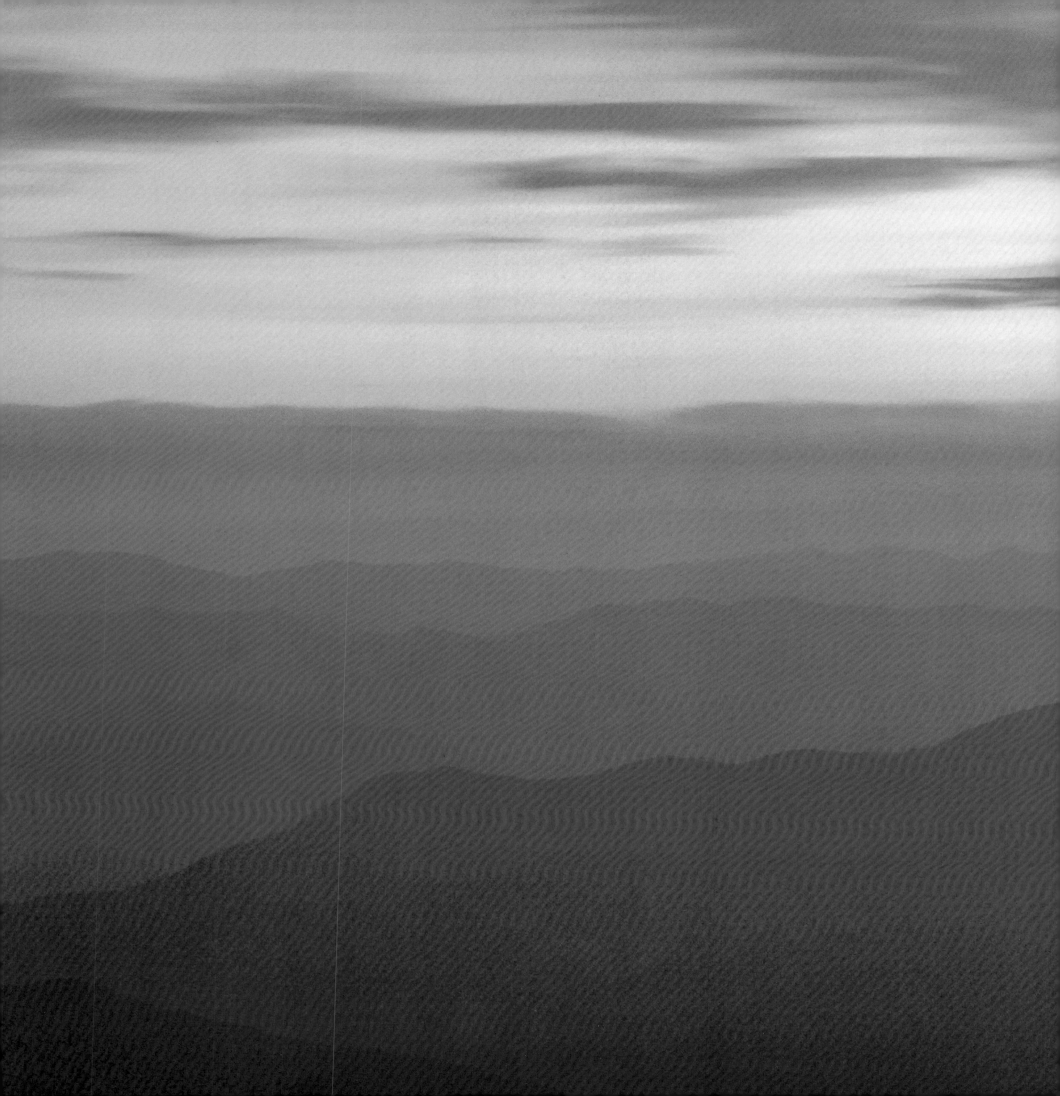

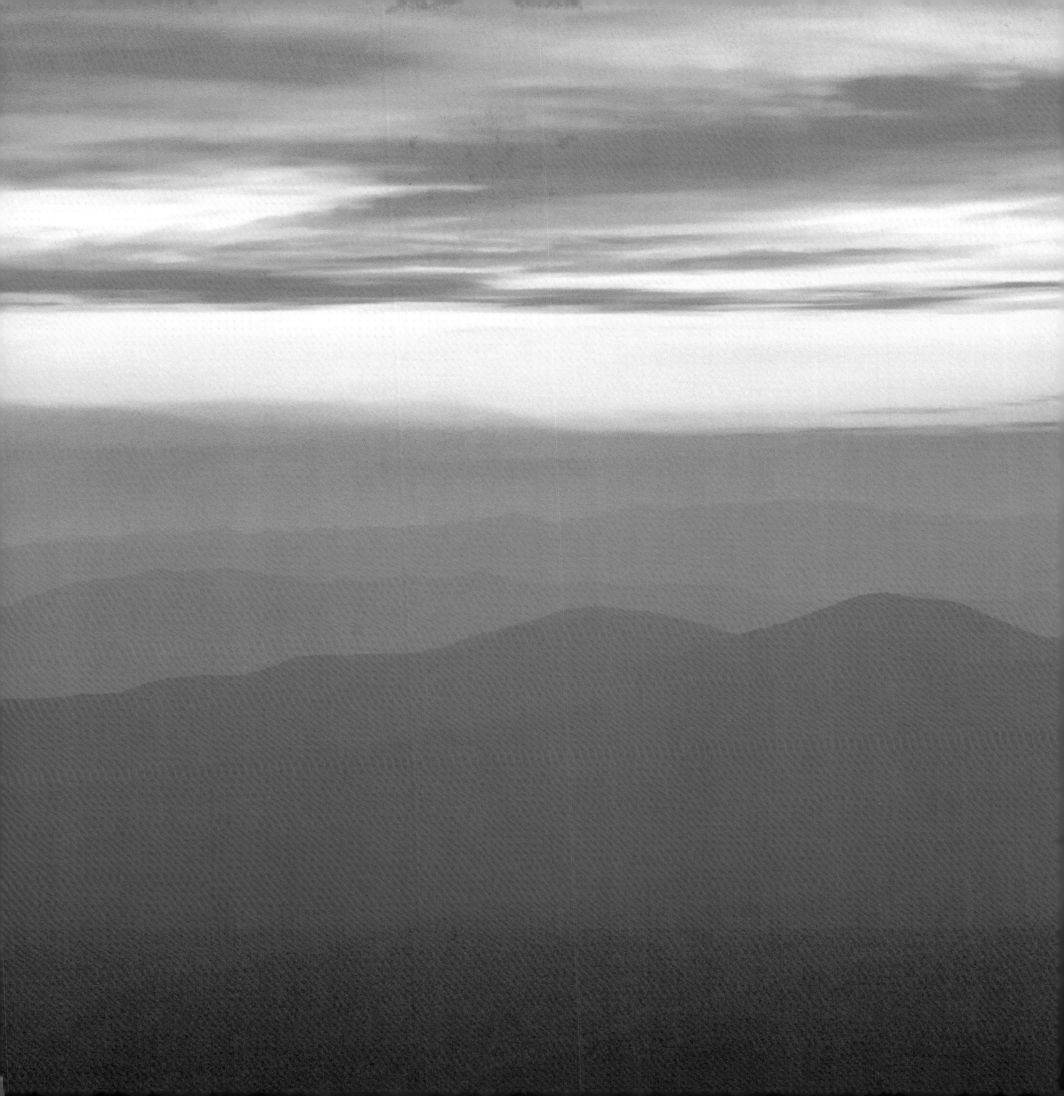

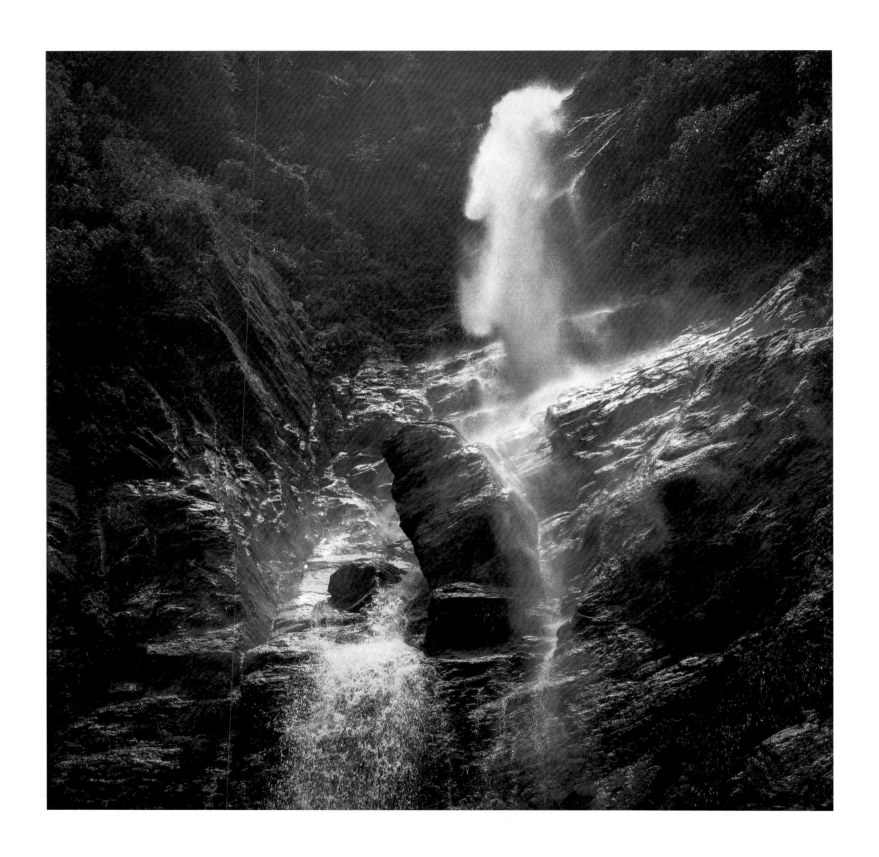

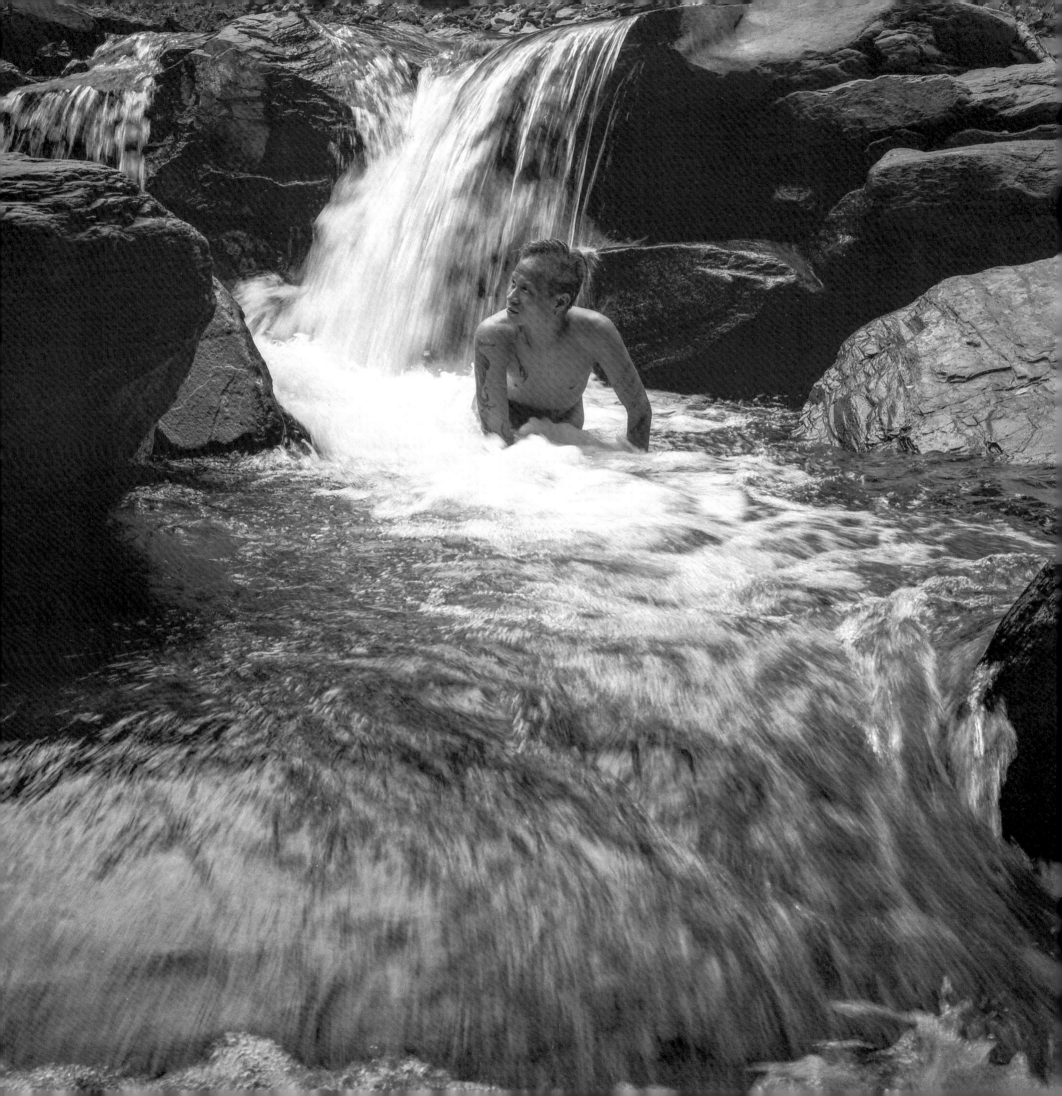

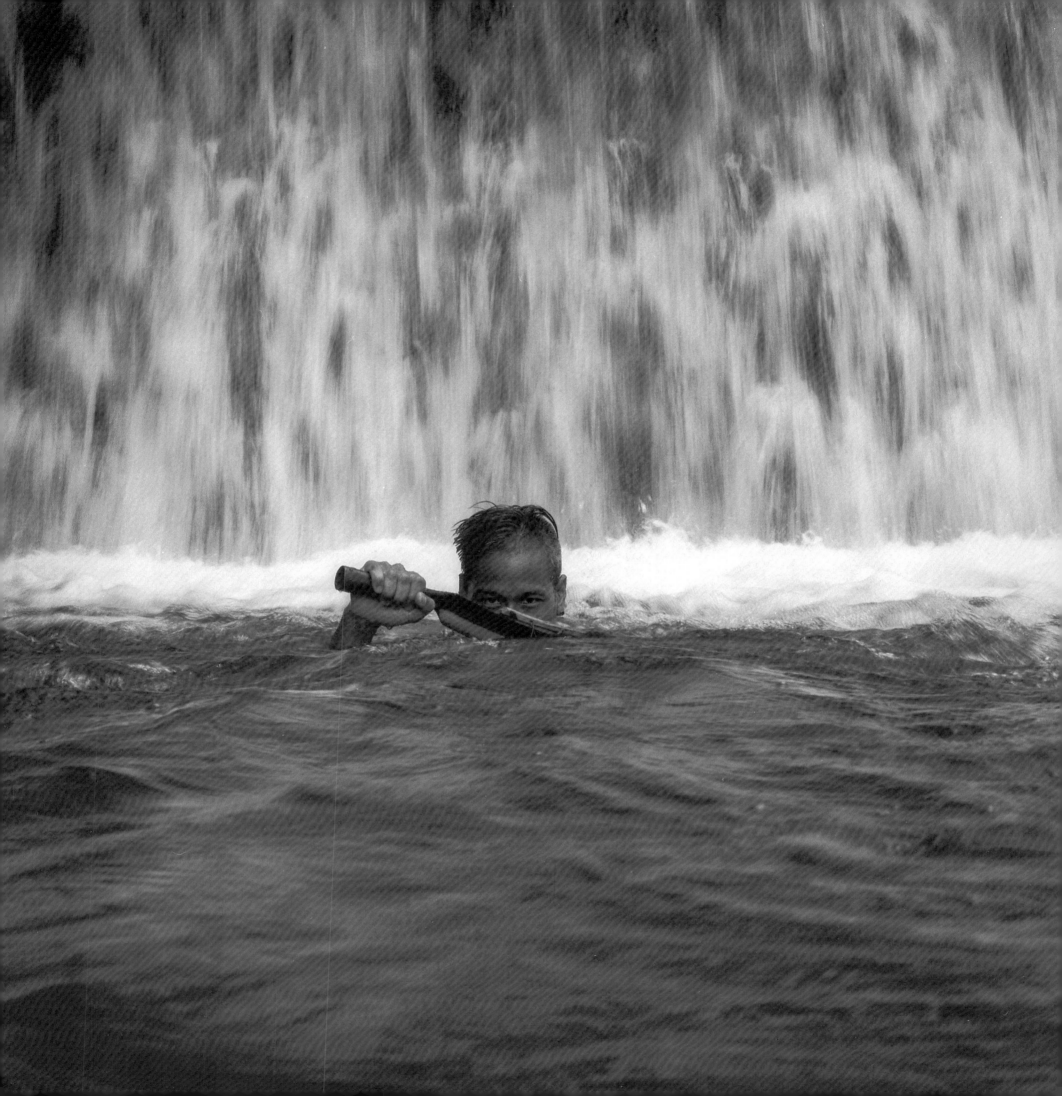

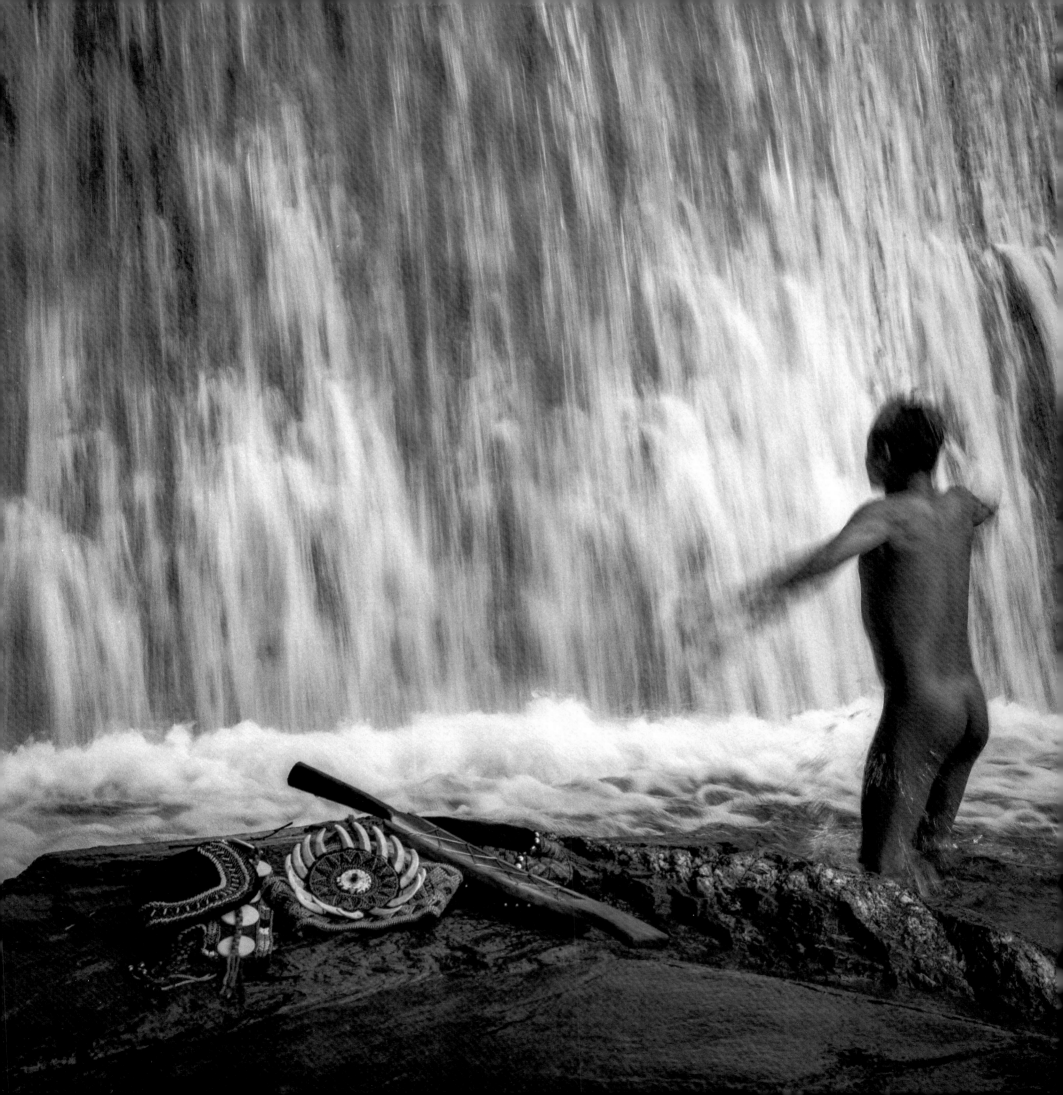

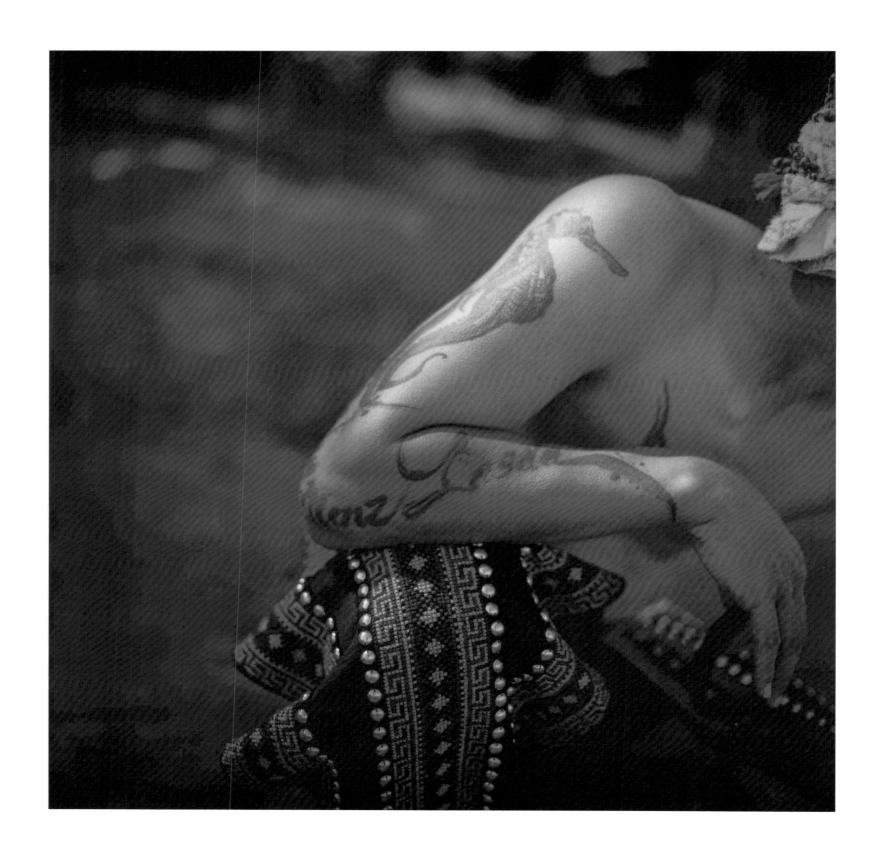

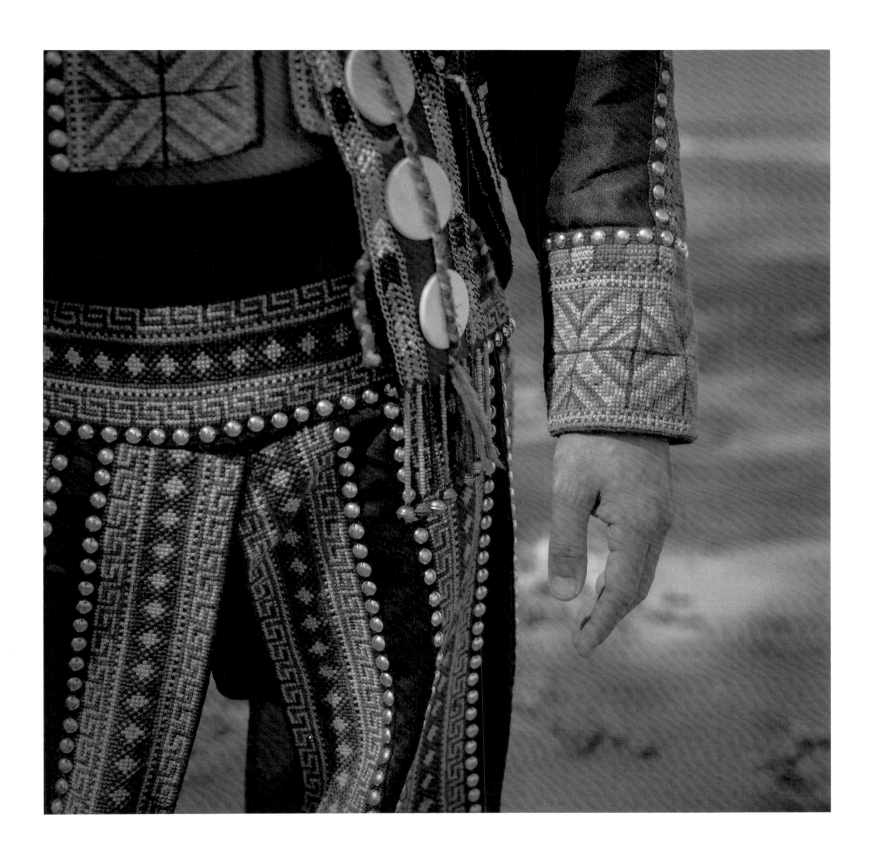

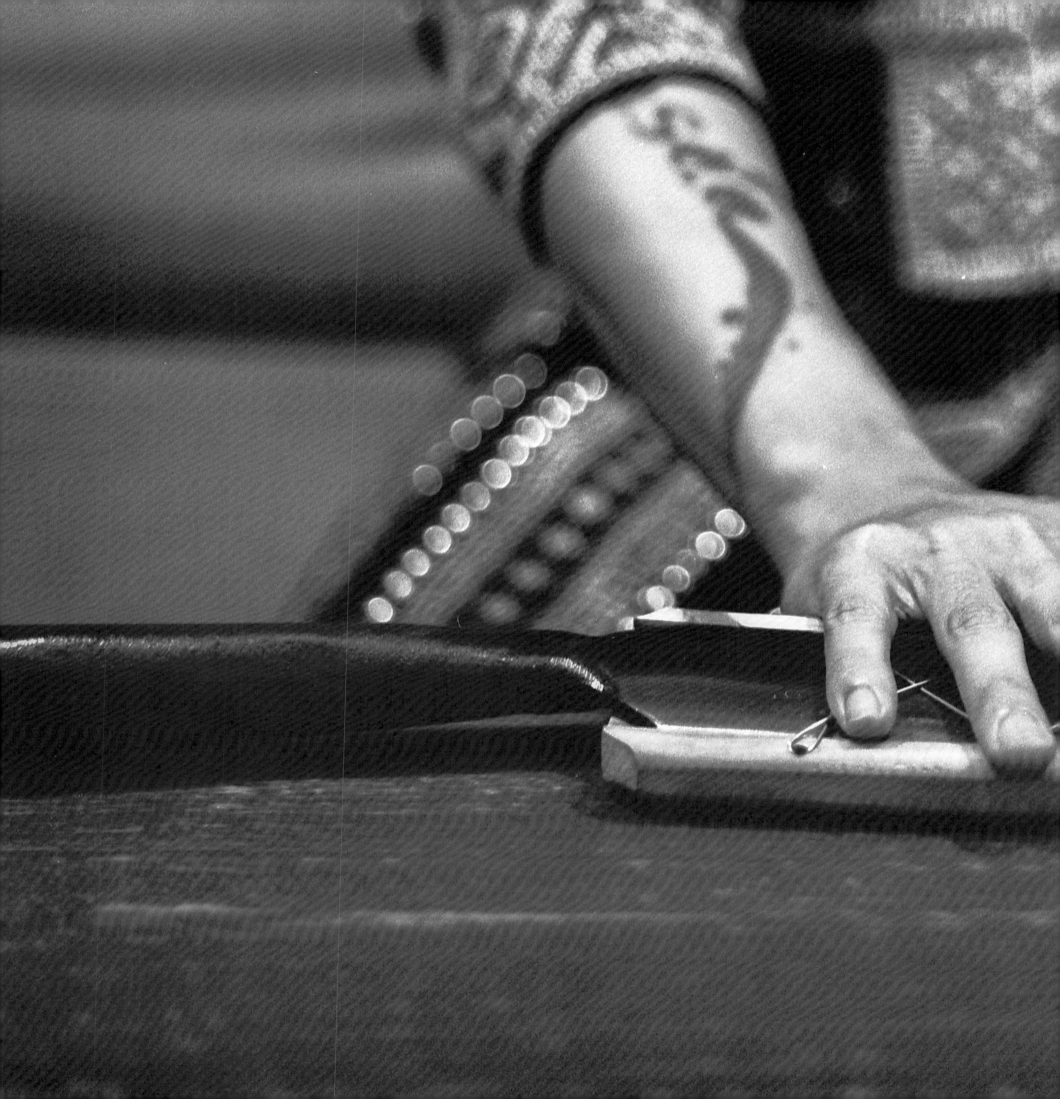

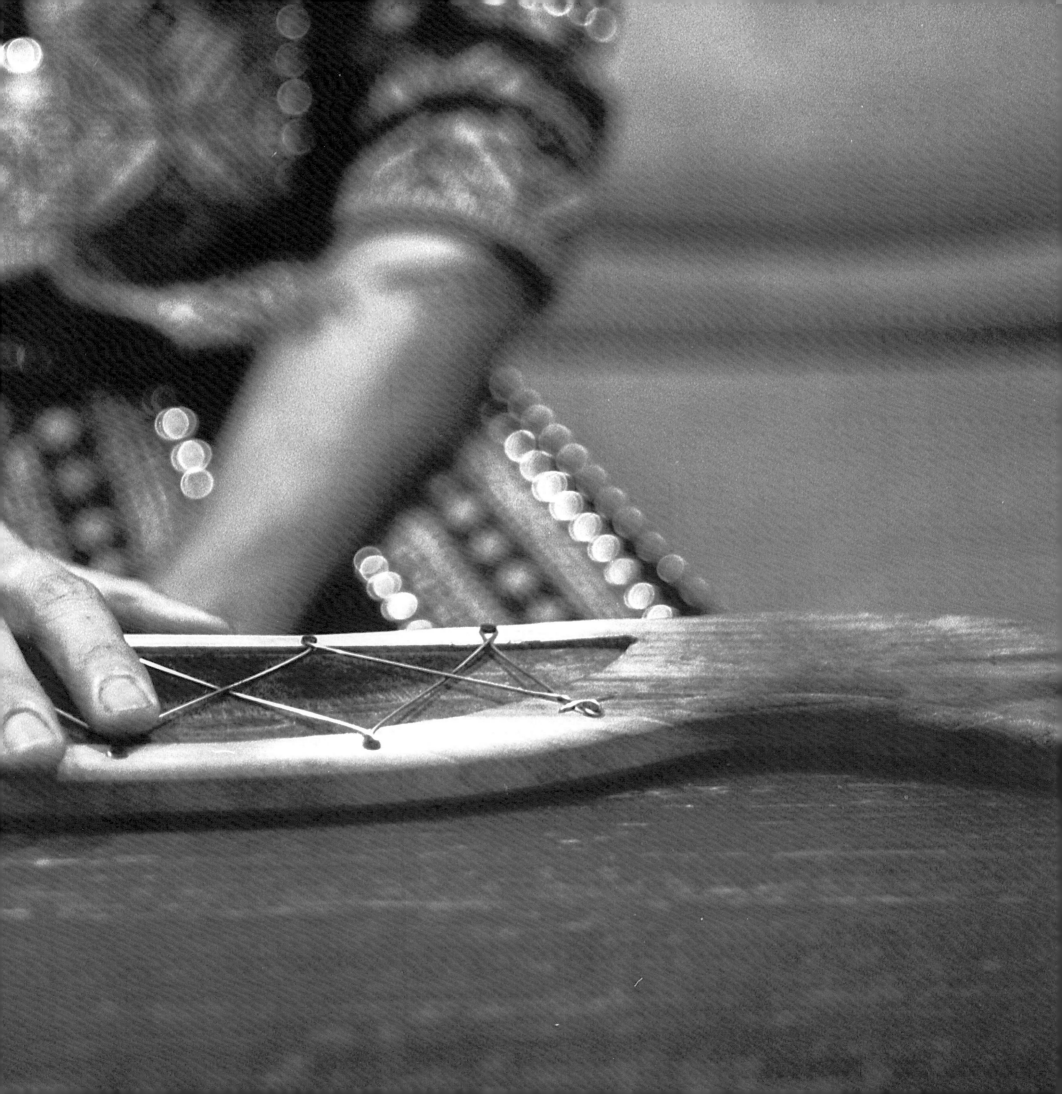

我真正開始直視自己的族群認同，是始自五年前父親過世之後。我父親一輩因為祖父職業的關係，與部落的親密度稍有不足。父親與祖父身為軍人，在這兩代中，這樣的職業關係使得家族整體在生活及教育方面與部落相比都較為優渥，也因此與部落形成了一種看不見的距離。這樣的斷層也使我與同輩的兄弟姊妹對於部落更加的疏離及陌生；無論是在城市還是部落，對於當時的我似乎都失去了「家」的意義，也不再有「家族」的鄉愁。我認為這對我造成了頗大的影響。在父親過世的前幾年，我時常回到部落幫父親工作整地及農耕，父親總希望能在台東的故鄉中為我們備有一塊迦南美地，希冀我們不管在任何打擊下都還能存有一點盼望與退路。在那期間，因常與父親在故鄉工作，使我重新與部落培養了較深的連結，父親也帶我回到家族最初的發源地—巒山。那段時間裡，我重新認識了我的族群及血脈，同時也重新修復了我與父親及家人之間的感情。

　　我身為這社會的一份子，對於我的血統經歷了迷惑—背負—尋找—重生這樣不同的心境轉變。在部落中我看到了年輕人口不斷流失，他們力求自己的身份得到證明，並亟欲捍衛族群權力而與社會征戰。在城市中我們也需直面不曾停止的與自身衝突的社會成見，無論是隱形或顯性的態度，甚至是來自同為原住民身分的相互競爭。但感到幸運的是，如今能在我們家族中看到一些兄弟對原住民議題的重視及關注，有機會能為我們的身份「發聲」，甚至是用作品來「表現」我們對生活及社會的吶喊與情緒。

<div align="right">Lasda Takbanuaz

2018</div>

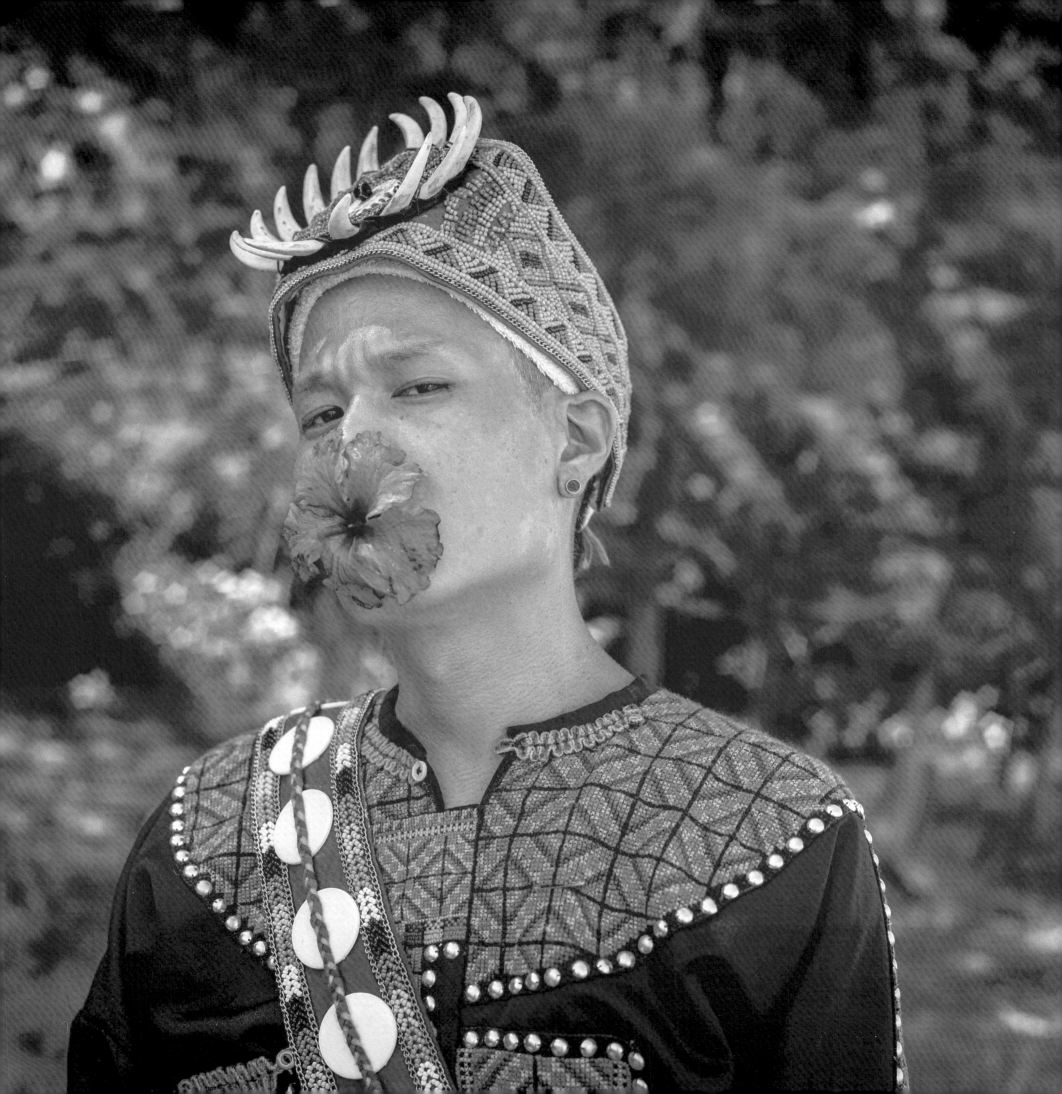

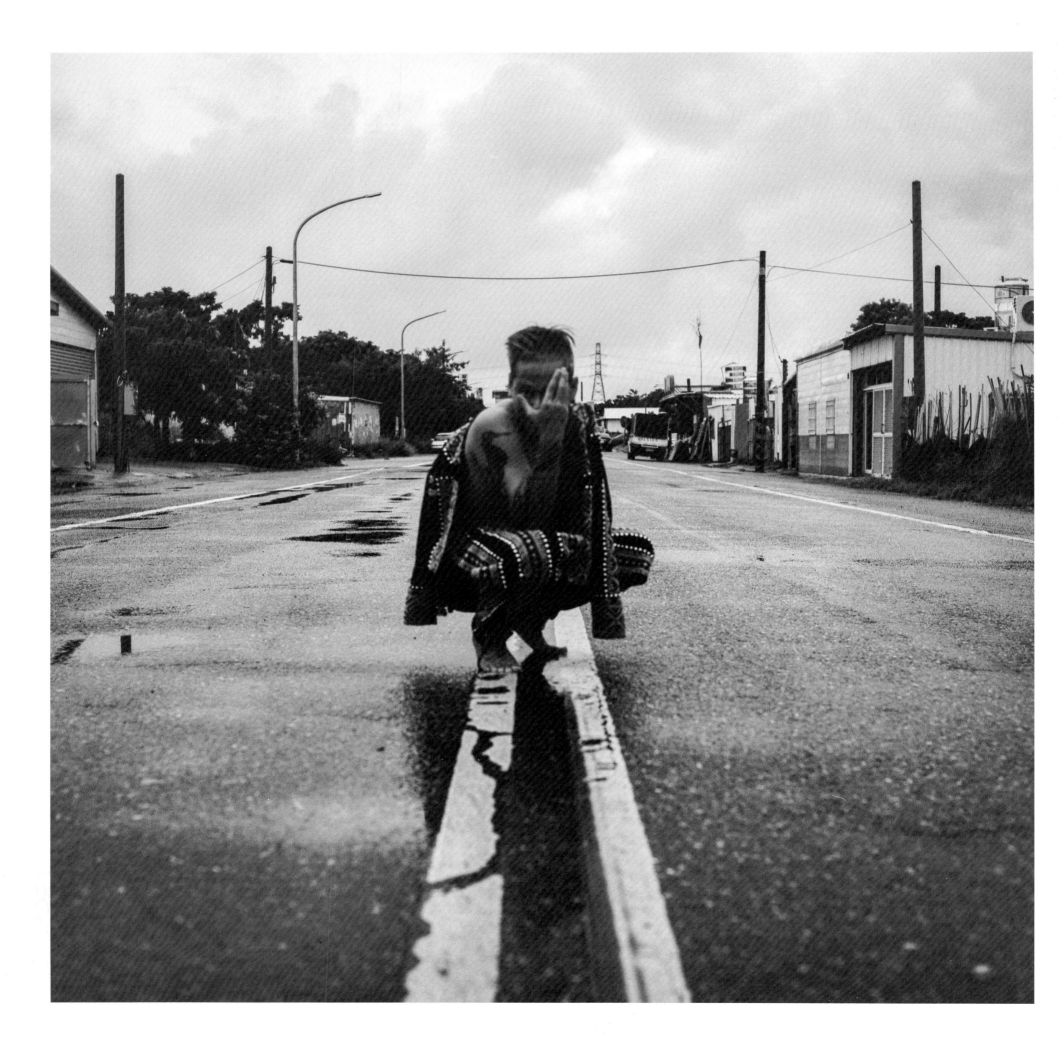

現在回想當初的種種，那時似乎背負著某些標籤。當我意識到我與其他人或種族有所不同的時候，為了迎合他人的看法，便開始極力的想表現那些所謂「標籤」中我認為自己可以做的更好的地方。像是「很會喝酒」、「隨性樂觀」、「體耐力持久」以及「特立獨行」等。 似乎相當隱匿的被社會既定且要求我們應該就是要這樣，而我們也應該要有相對應的表現。 反之，如果做不到，將在某程度上被漠視，甚至被排擠。

　　我的血統由母親(中國福建)及父親(山地布農族)兩個在台灣的族群(本省人與原住民)聯結，這樣無法改變的事實使我不管在都市或是回到部落都有一種寸步難行的感覺。彷彿我兩者都是，但也兩者都不是。在都市中，其他人以相異的眼光來審視我：回到部落，似乎又與部落的人格格不入。使我不管身在何處都有一種離異及脫節感。

面對台灣的升學制度，甚至是在班級團體中，開始有人以種族來作為彼此間的區分及玩笑時，

我才開始發現，原來人與人之間的相處並沒有小時候所想的那麼單純。我在國中時最常被稱作「番

仔」、「山地仔」（在台語語系裡面「仔」有輕蔑的意思）。那時我們似乎並沒有意識到何謂歧視

及言語暴力，其原因追究起來，我想是因為長輩稍作修飾的言辭保護了年少的我們。但那時的我

只意識到「自己與他人不同」以及「被這樣叫感覺有點不舒服」。這樣茫然且壓抑的情緒直到升

學壓力開始逐漸有了心理的變化。那時的同學們對政府給予原住民的補賞抱著輕視的態度，用調

侃的語氣說「反正你們有補助和加分」，以此來紓解內心對原住民的不解、嫉妒和不平等的情緒。

　　而進入職場時，在同事或主管得知我是原住民身分後，對於我們原住民族群的直觀認知就是：

「很會喝酒」、「生活隨便」、「較沒有知識（書不讀好）」或是「私生活很亂」這樣的偏見。甚

至這些不平等的認知都體現在平時的對談甚至是工作安排中，還有較為直接來自不被看好的感受。

這也造成了當初我在出社會初期甚至是職場與各種聚會中，並不喜歡主動告知他人我真正的身分

或血統。

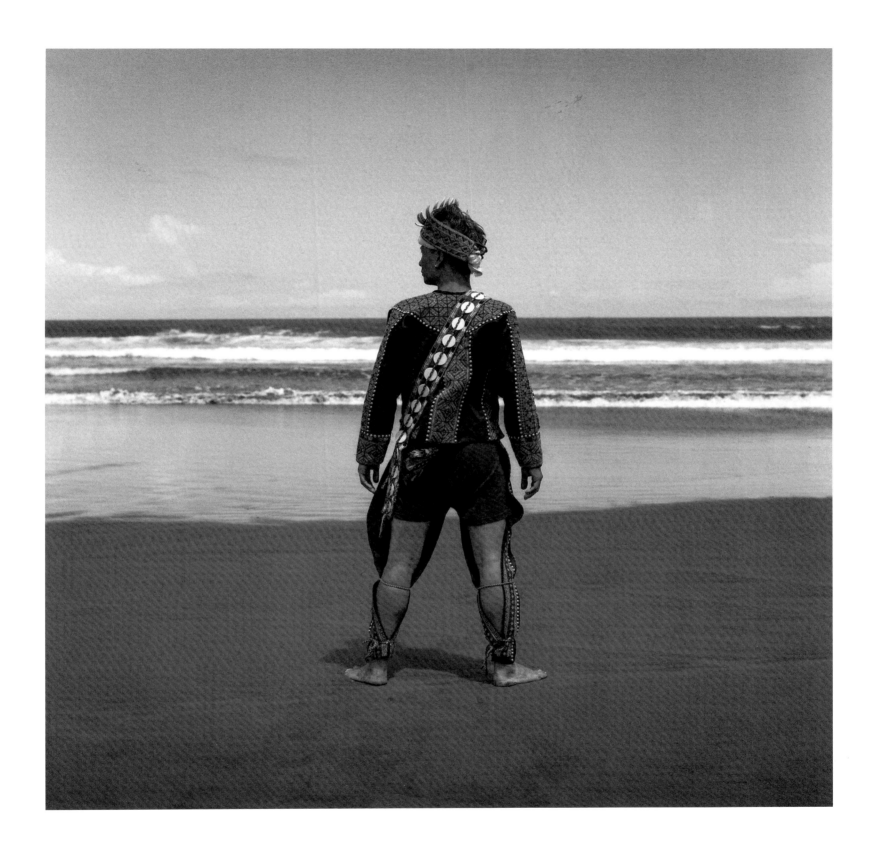

在每個年齡階段，社會大眾對於我們（原住民）所產生的看法及原住民代表的角色都在不斷的演變。台灣在 1947 年"228 事件"之後的 38 年都一直是處於戒嚴的狀態，而我們剛好在戒嚴結束前幾年出生，直到九零年代初期，我的國中時期，因著當時的（族群對立—戒嚴—1996 首次總統直選）民主轉型正義的逐漸抬頭，由先前國民政府對於原漢對立與衝突問題持續宣導之下，使得社會上明顯的偏見與言語上的隱性歧視直接由上一代強加在我們這一代身上。

LASDA TAKBANUAZ

敍

福爾摩沙的守護者

這系列中，我用藝術去呈現畫面，盡可能呈現原住民族群應有的獨特性及文化特質。在畫面中的情緒或表現手法，所專注的是現今原住民族群的心理層面以及他們與社會的連結。因歷史所產生的問題及影響並不于單一族群或單一人物。當我攝影時，我盡可能使人物的臉部模糊化或刻意不拍攝全臉。藉由長時間曝光的手法去打破時間所給予的束縛，藉此去闡述他們的先祖輩於這片島嶼上的生活及過程；在影像的詮釋中藉由擬像與再現 (signifier)，去 表現從古至今的整體環境所帶給他們的生活與心理情緒 (signified) 的影響。作品裡涵括了他們對自然的敬畏及那種無憂無慮的生活，直到殖民者的逼迫產生轉變，那些從生活的最根本到心理層面上的改變，即為影像中最為重要的張力。

　　令人憂慮的是，無論是在生活中的居住權、文化保留、就業能力、土地繼承、教育，甚至是青年高自殺率，到心理層面對社會的懷疑與自我否定。這些問題在原住民教育與文化水平有限的情況下愈演愈烈，時間與歷史所推進的結果導致社會地位框架及原住民與漢人之間的權力分配問題至今依舊存在。

<div style="text-align: right">

鍾 煊

2018

</div>

原住民在不同的殖民時期有著不同的稱呼，但不外乎都是矮化或歧視的字句。直到九零年代

初期，才被正名為「原住民」。而原住民一詞的意思即是「原本生活在此地的一群人」。

　　台灣曾經是一塊極為美麗的島嶼，相傳也是南島語系的起源。原住民的先祖甚至可以被稱為

福爾摩沙的守護者。他們同樣有著自身文化的驕傲，規律且自給自足的在這塊島嶼上生活著。他們

謙卑、樂觀、單純、善戰，勇敢且尊敬自然。但礙於沒有受到平等的教育與知識，因外邦人一次又

一次的侵入，他們在台灣的歷史上不斷被利用，壓榨，甚至被屠殺。

國民黨來台前，台灣原住民對中華文化還尚未理解與準備充足。國民黨執政後為使方便管理，快速的用高壓與軍閥的力量推行政策，而這種方式使原住民對國民黨政治詭理推行的過程產生反感與衝突。在教育方面，推行管理政策時宣導使用的文字敘述與原住民本身的語言產生距離與分化，同時也一併給社會大眾帶來了既定思維：原住民沒有文化及粗蠻。而在民間管理上原住民也因多方壓力使得語言由原生母語逐漸改為中文，原有血統的名字也被改為漢化姓名以方便管理。國民黨所實施的相關政策大大改變了原住民本身應有的傳統結構，也同時改變了他們對原生族群的文化認識深度。進而使現今許多原住民對於自身文化感到自卑與迷惑，變相的否定懷疑原生文化及血脈，只因必須使自身與現今社會接軌。

　　他們曾經是與自然最親近的一群人，但因社會變遷和時代背景改變，迫使他們在社會演變的過程中被動或主動的遺忘了自身應有的傳統文化及信仰，最後不得不在歷史演進的洪潮裡求生。當然他們至今仍有少部分人還是堅持遵循及延續著祖先的教誨和文化。直至今日，原住民仍在成長的過程中不停自我否定和懷疑，甚至在是否應該為了更好的融入社會而隱藏自我身份的漩渦中掙扎。原住民一方面有著對現代文明的憧憬，同時也必須持續與社會體制抗爭。而面對國家執政公權力持續掠奪甚至破壞侵佔本應所擁有的土地與資產，諸多矛盾與情緒衝突，使得自身及族群在社會的定位始終漂浮不定，而這也是現今許多原住民面對的現狀與問題癥結。

台灣原住民是一群樂觀，隨遇而安，與自然共同生活的一群人。但隨著時間演進，其發生了

較為明顯的社會變化。這或許可追溯至 17 世紀初期『荷蘭聯合東印度公司』進入台灣，在此之後

便開始了台灣不一樣的族群融合及改變。原住民族群在台灣這片土地上持續了四五百年的被殖民

狀態。從 1622 年荷蘭、1683 年滿清政府、到 1906 年日本，在這之間持續的被武力迫害、打壓、

統治及控管，一直到中國國民黨在 1949 年從中國遷移到臺灣。至今原住民族群依然在為了更好的

生活環境以及與其他族群共同努力被社會重視的情況中，持續抗爭著。

福爾摩沙的守護者

鍾 煊

福爾摩沙的守護者 (《Formosa Aborigines》) 系列曾獲殊榮無數，其中包括：

榮獲 2019 年 Monovisions 攝影大賽美術及肖像系列榮譽獎

第 13 屆 Pollux 國際攝影比賽純藝術專業類別、紀實攝影與文學專業類別、肖像人物專業類別榮譽獎

獲邀參與第二屆千尼亞國際攝影節

美國中西部攝影中心 - 國際肖像攝影比賽展覽

第 12 屆年度藝術家圖書研討會競賽榮譽獎

第 34 屆切爾西國際美術大賽現金獎

2019 年 ESPY 攝影大賽展覽

美國喬治亞州亞特蘭大薩凡納藝術與設計學院 ACA 圖書館館藏

美國世界日報報導

台灣外交部 - 亞特蘭大辦事處報導

鍾煊

藝術家簡介

1985 年生於台灣高雄市

攝影師，當代藝術家

鍾煊是一位充滿熱情的藝術攝影師，十七歲時開始接觸攝影，大學期間自學了各種攝影技巧及概念，並在畢業前成為一名專業的記者。工作期間，他不滿意當時在藝術領域的定位與自我價值，因此毅然辭去在台灣的工作，獨自前往美國亞特蘭大薩凡納藝術設計學院 (Savannah College of Art and Design) 繼續攻讀藝術攝影碩士學位，進一步探索『攝影藝術』的本質。

進修期間，鍾煊有幸在亞洲、歐洲及北美等眾多國家參加許多活動與比賽，並發表過許多以亞洲美學為主的題材作品，讓人印象深刻。其作品結合個人獨特的視角，充滿了故事敍述與情緒描寫。其中《YuGen》《Solitude of the Sea》《Announcement》及《Formosa Aborigines》等系列，更在北美與國 際間獲得眾多好評。現階段，他積極推廣自己的攝影作品及分享自己的攝影見解，同時也積極參與 國際攝影展覽，期望逐漸展露頭角。

福爾摩沙的守護者 Formosa Aborigines

作者 / 鍾煊　　出版 / 鍾煊、黃佳欣　　排版 / 鍾煊、孫佳寶、王榮耀

製作銷售 / 秀威資訊科技股份有限公司　　地址 / 台灣台北市內湖區瑞光路 76 巷 69 號 2 樓　　電話 / +886-2-2796-3638

出版日期 / 2019 年 8 月　　定價 / NTD 2400

國家圖書館出版品預行編目

福爾摩沙的守護者 / 鍾煊作.
屏東縣竹田鄉：鍾煊，
2019. 08　112 面；　29x30 公分
ISBN 978-957-43-6807-5（精裝）
1. 攝影集
957.9　　　　　　　　　108011628